POR SIEMPRE

POR SIEMPRE

JOSÉ OLIVAREZ AND ANTONIO SALAZAR

Haymarket Books
Chicago, Illinois

Published in 2023 by
Haymarket Books
P.O. Box 180165
Chicago, IL 60618
773-583-7884
www.haymarketbooks.org
info@haymarketbooks.org

ISBN: 978-1-64259-837-7

33614083156520

Distributed to the trade in the US through Consortium Book Sales and Distribution
(www.cbsd.com) and internationally through Ingram Publisher Services International
(www.ingramcontent.com).

This book was published with the generous support of Lannan Foundation
and Wallace Action Fund.

Special discounts are available for bulk purchases by organizations and institutions.
Please email info@haymarketbooks.org for more information.

Cover and interior design by Eric Kerl.

Library of Congress Cataloging-in-Publication data is available.

10 9 8 7 6 5 4 3 2 1

Printed in Canada

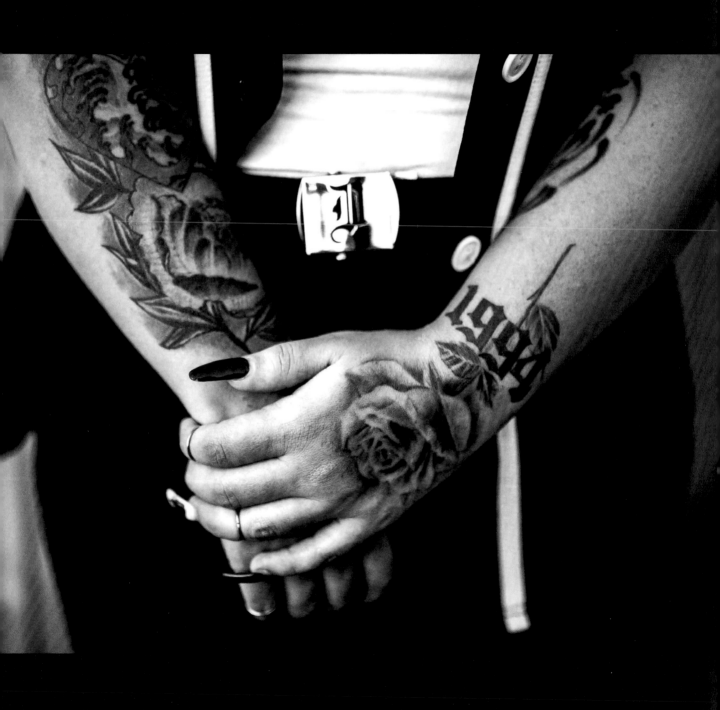

FOREWORD

NAIOMY M. GUERRERO

*P*OR SIEMPRE hosts poems and photo-graphs within three sections titled Lan-guage, Tradition, and Communion. It is a conversation between two poets using visual and literary tools to share a preoccupation with tempo-rality, connection, and the threads of masculinity. This collection asks: what does it mean to be living, creating, loving, on this land with many lands on our back?

Antonio Salazar's photographs interrupt the fleeting quality of precious mo-ments among loved ones and strangers alike. The photographs are meant to swell up chests in amazement at the capture of a life being lived authentically. The photographs invite a consider-ation of all elements mundane and profound that make up an evening, a day, a weekend, a life.

Salazar depicts daily life in the Phoenix, Ari-zona community he is part of. There are images of families bonding with their children after a long day of work, young adults smoking and engaging in acts of leisure, and folks laboring. Familiar Arizona state symbols include the state bird of cactus wren, and the iconic Grand Canyon. While Salazar's images are not necessarily about statehood, he offers them up as symbols for Phoenix. These photographs are

"These images insist on intimacy and tenderness."

scenic possibilities of what thrives in the desert. Consider the black and white photo of a man spin-ning a lasso above his head as he steps forward to gain momentum. He stands in front of a home with three windows and a white metal door grate whose design mimics the curls of the rope as it swirls in the air. He appears to be dancing freely as if the rope were a partner. Salazar happened upon the man one afternoon while driving through the desert and learned the man was practicing for an upcoming trip

back to his hometown where his people are known as master trick ropers. The last time he visited, his family playfully ragged on him for losing his touch. The photograph reveals him in the act of recuperat-ing a fading past, guaranteeing its existence in the future.

These images insist on intimacy and tenderness via their setting in private interior spaces as well as quiet moments in public places like the car shop, inside of a vehicle, and a family party in an aunt's backyard. A man wears a black durag and shirt in the bathroom staring at himself in the mirror while he shaves. He is at ease, disarmed, safe in the com-fort of his home. A different man is walking his dog on the street in slippers and seems to be pausing, perhaps reflecting on the sky and landscape before him. The photos grapple with the question: How to

render a permissible masculinity capable of holding the fullness of these subjects?

We are encouraged to view these subjects without the violence that patriarchal masculinity requires. In the images where boys, children, and men are interacting, there is a softness employed in an effort to preserve innocence. While looking through these photographs, it is possible one might find a missing puzzle piece you may want or need, a reminder that you are accompanied in your quest of trying to make sense of the visual lexicon you were raised in. There is often a child looming in the background or foreground of these photographs, perhaps a gesture towards a futurity that is innocent, and carries with it the ease of that scene into the future. In this way, Salazar's goal of disrupting the continuum of time and pausing for repose in a moment that is restorative is accomplished.

Like Salazar, Olivarez is concerned with how the past offers a vantage where you can contemplate stagnation and possibility:

> but then again, the poem comes from maíz.
> generations of gente de maíz surviving
> (the photo doesn't want to say against all odds—
> that kind of talk is corny) & how
> do you think that happens? the poem can't define
> love, but it can tell you about baby baths in sinks.
> warm water poured on baby hairs. a baptism.
> mothers & fathers with rent scratched
> into their foreheads kissing baby cheeks.
> birthday parties where the whole block shows up
> & you don't know who's blood
> & who showed up for the free beer.

There has been a renewed commitment among writers, poets, and artists to probe the promises and limits of a collective Latine/x identity. Latinidad itself is being aptly questioned for its own perpetuation of anti-Blackness, anti-Indigeneity, and violent patriarchal masculinity. Blanket terms and generalized categories made to encase large swaths of us under a common experience is tenuous at best. José Olivarez's poems are sometimes humorous, sometimes vehement, but always incisive in their critiques of popular representations of immigrant communities. They urge readers to employ different ways of perceiving.

Olivarez's poems insist on specificity, arriving at points of connection without glossing over the differences among us:

> the poem is sorry for ever glamorizing the struggle.
> enough of work. enough of struggle. the poem
> refuses to be a good worker. the poem vows to
> never
> be productive. huevón y flojo y qué? the only work
> the poem is interested in is working on a tan.
> the only struggle the poem will glamorize
> is the struggle of cracking open a coconut
> without spilling any milk.

Some of the main characters in this exchange between visual and literary poetry include masculinity, childhood, community, and, of course, love. Olivarez provides a narrative based on a poetic sensibility that is aware of its own engagement in the act of recovery. To read through *Por Siempre* is to see what bell hooks called "relational recovery" in action. Hooks argued that in order for men (or those who identify with a masculine subject position) to be able to love within the system of patriarchy, boys would need to be raised empathetic and strong; connected to themselves, to their community, and

*"Theirs is the careful dance
of nostalgia and imagining a future."*

to be able to "make community rooted in recognition of interbeing." Only once this solid foundation exists is love able to take root and flourish.

This solid foundation is only possible when there is courage to heal and undertake the task of relational recovery. Venturing into self-recovery starts by assessing what and how one learned about masculinity as a child. Hooks argues that a useful strategy is to isolate formative moments, core memories, and feelings that ensued but were ultimately suppressed as they were uncomfortable for others. Both Salazar and Olivarez are engaged in the act of relational recovery. Theirs is the careful dance of nostalgia and imagining a future. The alchemy is clear. They isolate the poison of suppression and couple it with the medicine of love to give readers a salve:

time. the poem knows
something about anger. hold it too long & it
 poisons the holder. can the same be said for love?
 digestion turns all tasty treats into the same shit.
 dead flowers attract gnats.
even misery is a show. the poem desires an
 audience.
a right hook to the temple will cure you
of whatever ailment you're holding onto. it's hard
to hold a grudge from the ground. when we suffer,
 we want a witness. the secret to taking a punch
is to accept it. the curse of being human is no
 matter how much love we get one day, we require
 more love the next day.

INTRODUCTION
JOSÉ OLIVAREZ

1.

Encountering Antonio Salazar's photos, I was struck by their force: men teaching children the proper way to fire a gun, tattooed men holding a razor tight to their cheek in the mirror, a child getting a bath in the sink. These images stayed with me. I kept looking. The photos reveal a deep tenderness. A man, teaching the child how to hold a gun, holds his child in the same way a suburban father in another America might hold his son or daughter, while teaching him how to swing a baseball bat. The same tenderness in a different context. Looking at Antonio's photos makes me want to cry. His photos remind me of all the Mexican men I grew up admiring and imitating.

2.

For many years, my author's bio started with the sentence: *José Olivarez is the son of Mexican immigrants*. I started using this sentence at the behest of poet Eduardo Corral during the 2016 presidential campaign of Donald Trump. Trump targeted immigrants, and continues to say awful things to disparage them. My statement, my bio, counters that negativity with the reminder that immigrants have positively contributed to the United States. We're good people, too! We're not criminals. Now, I can't help but be exhausted by the eternal chase to prove (to who?) (white people?) (government officials?) that my people are virtuous enough and *perfect* enough to receive basic human rights. The truth is: migrant people exist in an abundance of different ways. And still, they all deserve dignity and basic human freedoms.

3.

Antonio's photos root themselves in a particular corner of Latinidad—not the dreamers, and not people with any notion of one day assimilating into whiteness. People with their own traditions, languages, and communions. Sometimes those moments will look downright sweet and intimate. Sometimes those moments hint at deep violence and trauma. I love these photos because of the care and love that Antonio takes in his craft. These photos are beautiful. It's clear that Antonio respects and has love for everyone he shoots. It's clear he isn't judging anyone for how they live their life.

"Imagine the photos and poems as friends catching up."

4.

When Antonio approached me about collaborating on this book, I had a lot of reservations. I'm not from Phoenix, AZ. I didn't grow up handling guns. The photos speak for themselves. The photos don't need me to narrate them. And yet, the more I looked at Antonio's photos, the more they spoke to me. Like Antonio, my art is inspired by masculinity, and, in particular, those moments where the machos reveal the softness and tenderness within themselves. I thought that I might be able to add a different style and music to accompany these photos.

5.

For this collaboration, the prose begins with this device: "The poem…" I chose this opening because I don't want a first-person narrator. The poem is its own character. I want the poem to ask questions and note and prod and have a conversation with the reader. Some of the poems begin with images taken from Antonio's selections. I used the images' subjects and themes present to begin my own poetic threads. I think of the entire book as poetry. Antonio's photos are visual poetry. They are notable for everything they show and for what they don't. For example, for all the photos of guns in the book, there are no acts of violence in the book. There are no funerals. There is no death. Like an expert poet, Antonio uses absence to make the images stronger. My poems are still rooted in my own life. The photos and the poems talk to each other. Sometimes about the same subject. Sometimes one or the other will jump in a different direction. Imagine the photos and poems as friends catching up. Having a conversation that you're invited to participate in.

6.

I want to end by saying thank you to Antonio Salazar. Thank you for trusting me to collaborate. Talking to you and trading art is a dream. Thank you for letting me be a part of it.

ARTIST'S STATEMENT
ANTONIO SALAZAR

How did you and the poet come to work together?
José [Olivarez] was touring for *Citizen Illegal* and made a stop in Phoenix, AZ. A mutual friend of ours got us together, and we drove around and saw these key spots of Phoenix at night all lit up in the desert. We shared photographs, and it just felt like a natural conversation with someone who feels just as strongly as I do about the heavy connections we're trying to spark, not just in these artistic spaces, but in everyday life.

How do you hope *Por Siempre* will engage with the communities it will enter?
I hope people find peace when they engage with *Por Siempre*. I hope people are able to see what another way of life is like without being far removed from their own. I hope it brings a feeling of peace because they see they aren't alone.

How does a photograph come to be? Speak to inspiration and your process, and how the photography speaks to poetry and vice versa: poetry to photography?
A photograph comes to be on a hot day with a cold beer and just some friends and family. Friends that feel like family and the weight of memories that you want to add too. Having all these experiences wash over you. Something tender. Or something fierce. Just got to make sure you're there to take the picture.

And always trying to feel what is that spark that is gonna stick with us long after the photos gone.

The process of making photographs is based on this: the time it takes to be outside and amongst people, what it is I'm feeling, or what speaks to me in these spaces, what makes me want to hit the shutter. Heavy things and light things but they shape your eye, and it just helps you zone in on moments that speak to you. Photography, in certain aspects, is visual poetry. Its moments make you feel so much, while only showing you a piece of the world. And poetry speaks so much with so little words because it's something in the words and tones that we read and listen that can stay with us after the moment's gone. Just like a photograph. It's pieces of the human condition.

Speak to the communities being represented in the photographs in *Por Siempre*. What do you hope their presence in this text will represent or show?
We're built to last! So, I want people to see that. Forever. We tough and we grow.

What is unseen in these photos and poems? What wants, desires, notions are lying in the subtext?
There in the photographs is a yearning for connection. A stronger desire for family and community, like feeling you are a part of something a lot bigger, especially in these times.

"We're built to last!...Forever. We tough and we grow."

I was always curious about photography but never got into it until I got my first smartphone with a decent camera. I'd just take photos on the go and download all the photo editing apps. But it wasn't enough, so I saved up for my first DSLR, which was a Canon T3i, and from there I just became obssesed.

I started really getting into photography in Phoenix. I would work late nights on the southside, so when I would get off work I'd just cruise and take the streets all the way home with my camera in my lap, hoping to catch a glimpse of what Phoenix was really like.

The Latina/o/Latiné/Latinx community in Phoenix, AZ is huge and packed in together. There's still some separation within our own communities—especially with xicanos, mexicanos, and our Indigenous cousins—but we all share the same spaces and live somewhat similar to each other a lot of the times. But like anywhere else, I feel like theres still a disconnect. For myself growing up, it was always strange seeing that, so I feel the work was kind of like my way of understanding the way things worked in the desert. When it feels like the whole world is rooting against you at times, with all the hate people carry in Arizona, the last thing we need is to hate each other. So it pushes me just a bit more to share my perspective on the city and people I love, to maybe leave behind this little piece of tenderness, so that can be a part of our history, too.

1.

Language

the poem is written by the son of immigrants. the poem wants
to thank his parents for migrating to the United States. the poem
knows his parents were thinking one day *mi hijo va poder escrbir*
los versos más tristes while riding across the border. the poem knows
he gets paid five dollars every time he writes the word border.
border border border border border border border border.
the poem knows he gets paid ten dollars every time he speaks spanish.
frontera. frontera. frontera. frontera. frontera. frontera.
the poem never turns down overtime. the poem is angry
his parents migrated to the United States.
the poem knows in Mexíco he would be unburdened
with being a minority. oh, to be born lower case. lower caste.
lower class. the poem confesses to never riding across the border
in the trunk of a car. it happened to someone else. the poem
understands relation is relative. relatives don't understand the poem:
mijo, why did you go to Harvard just to stay poor? the poem knows
he will never know the promises his parents made to stay alive.
the poem wears a mask. the mask is a bouquet of gardenias.
the bouquet is for your protection. if the poem ever dropped
the bouquet. the only thing remaining would be a fist.

the poem knows you are scared of guns—
black as they are, heavier than the plastic
ones you waved around as a kid, loud
& unmistakable. the poem knows guns
are ugly. that type of knowing is easy.
cheap. remix: the poem knows
there are so many guns we applaud.
a billionaire smiling on television
is a gun pointed at all the children
with percussion bands in their bellies.
that type of music is loud if it's your belly
or your family's belly & silent if it's not.
that type of music we play on repeat.
when the violence is neat, we nod along.

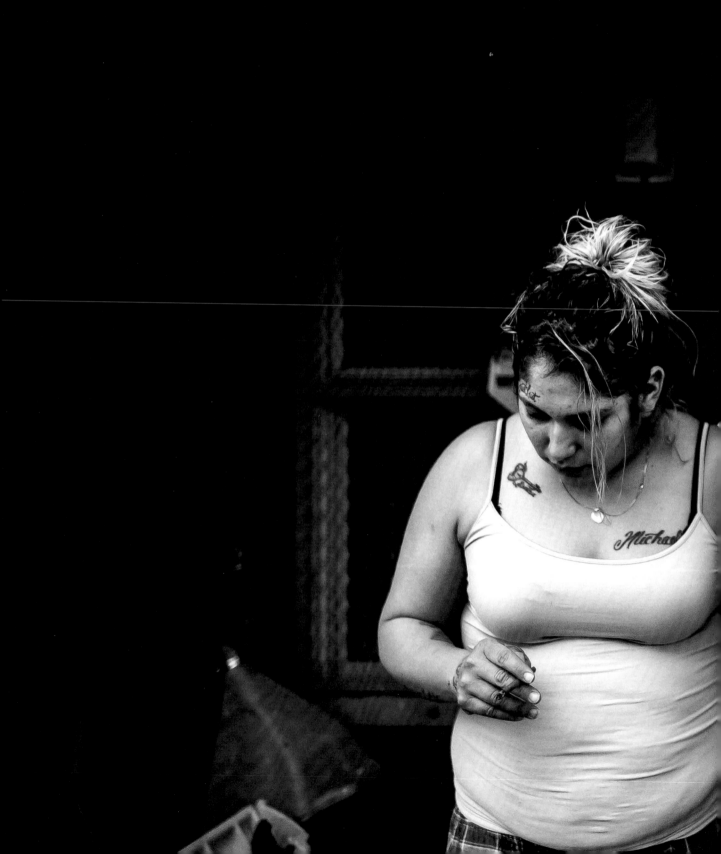

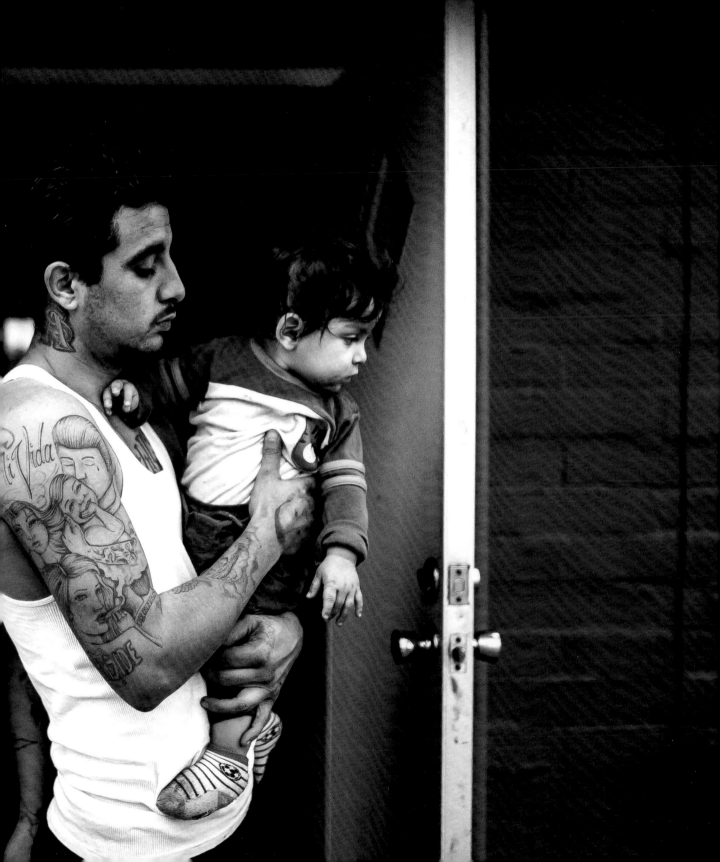

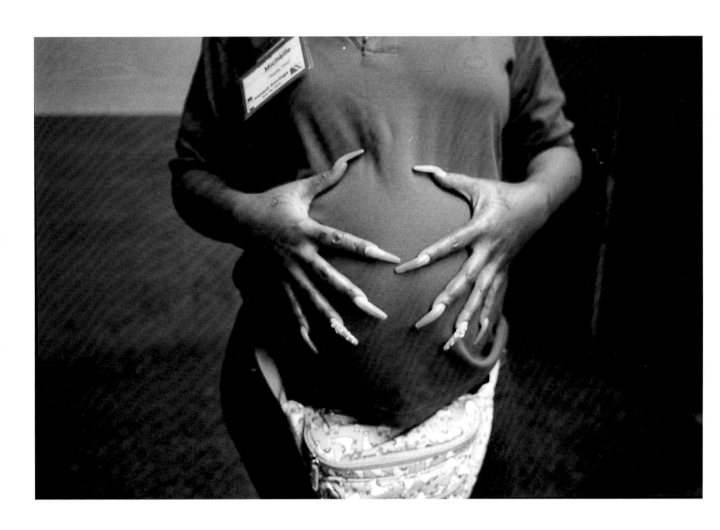

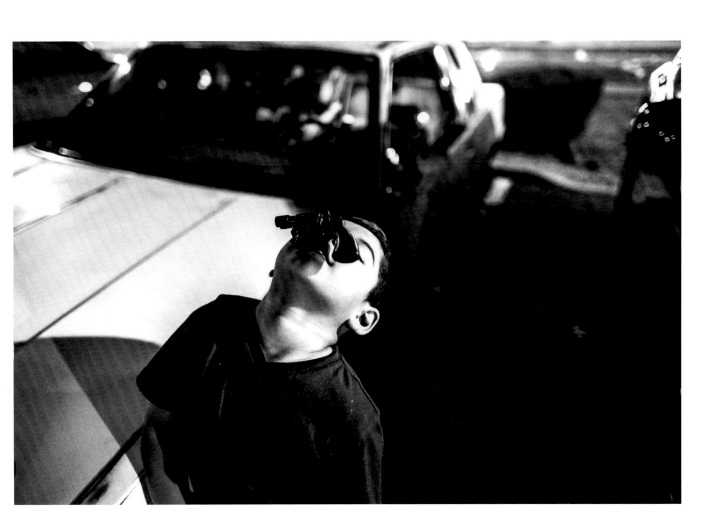

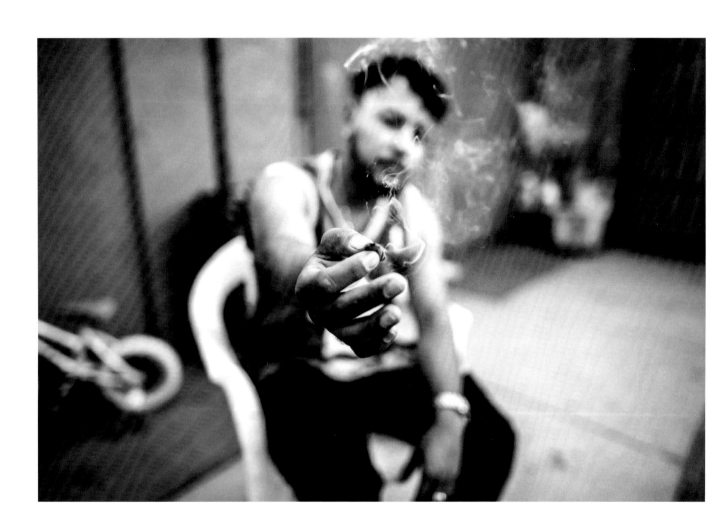

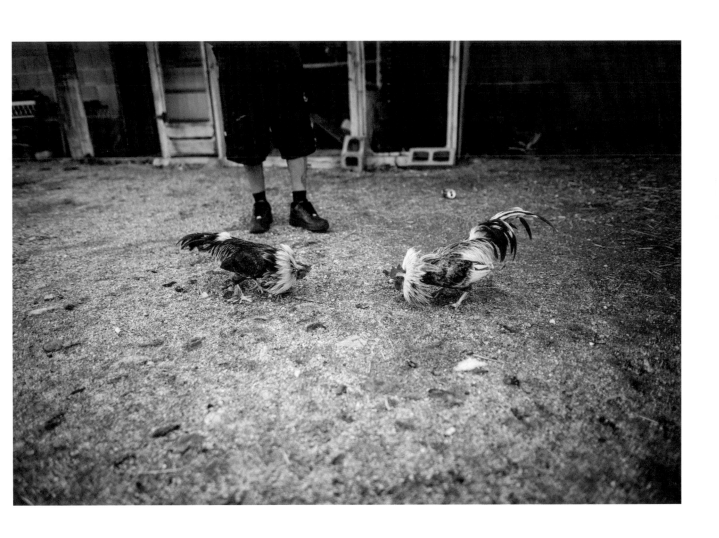

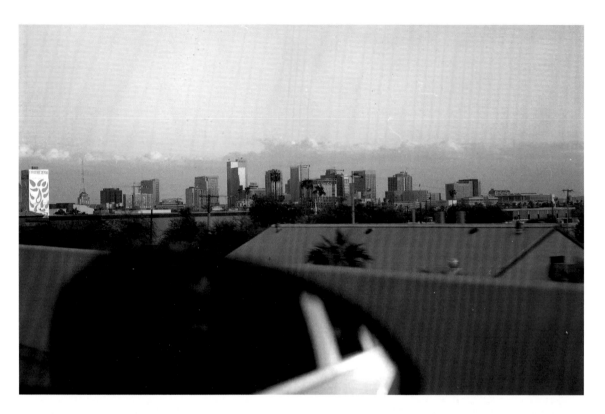

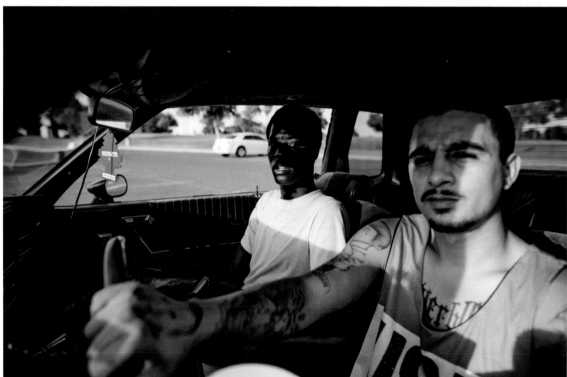

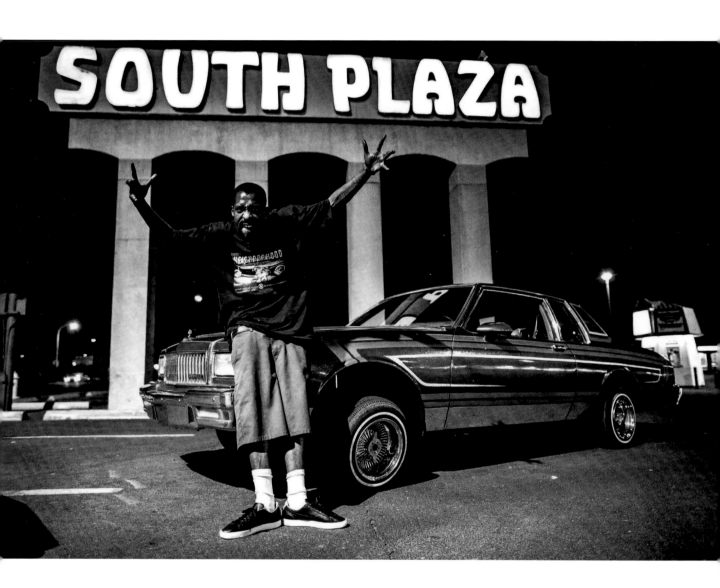

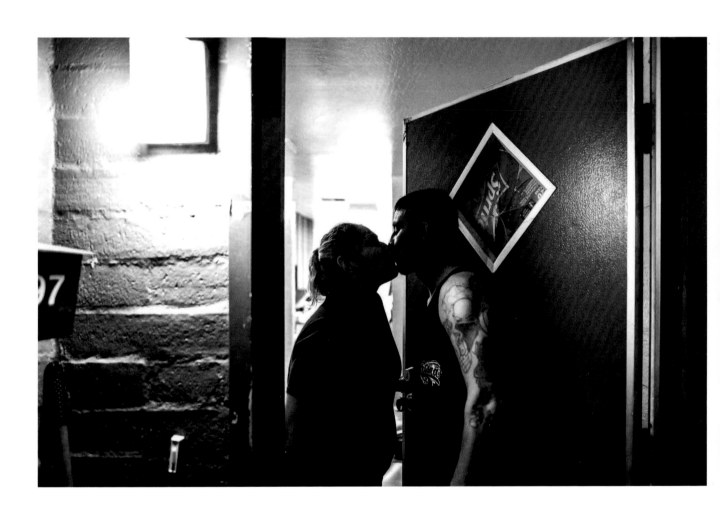

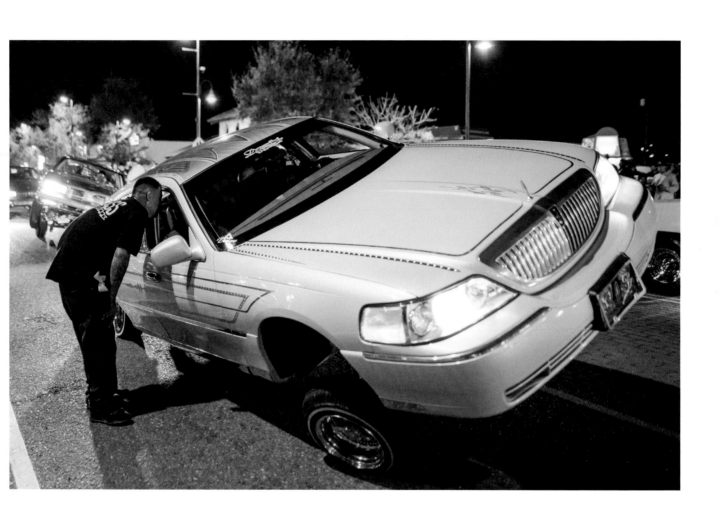

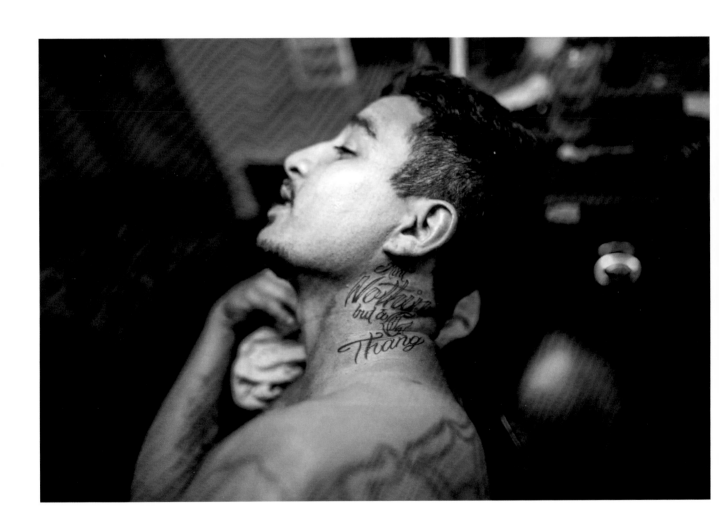

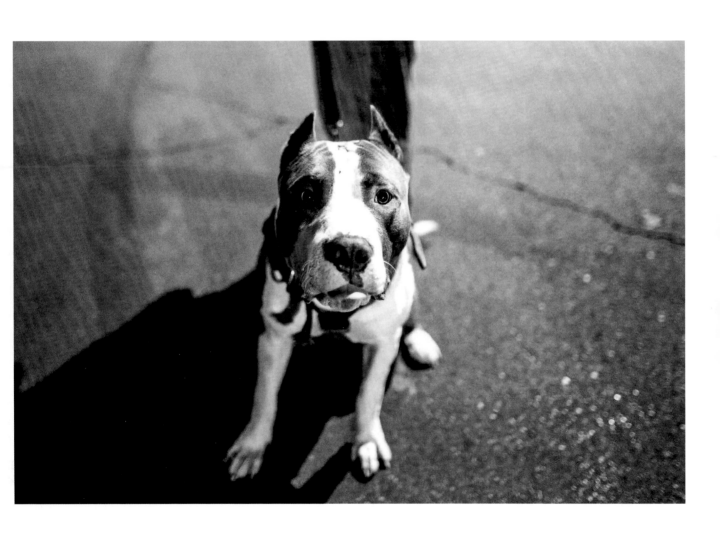

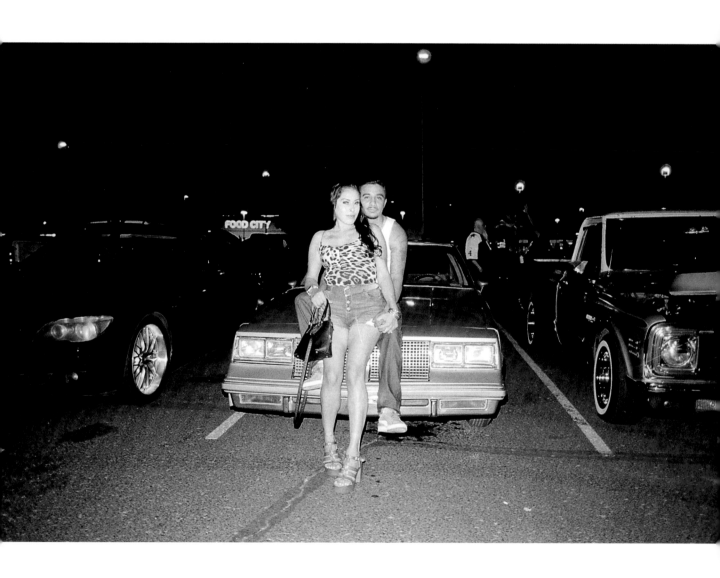

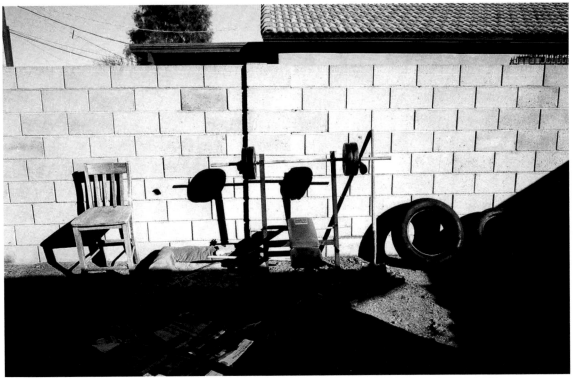

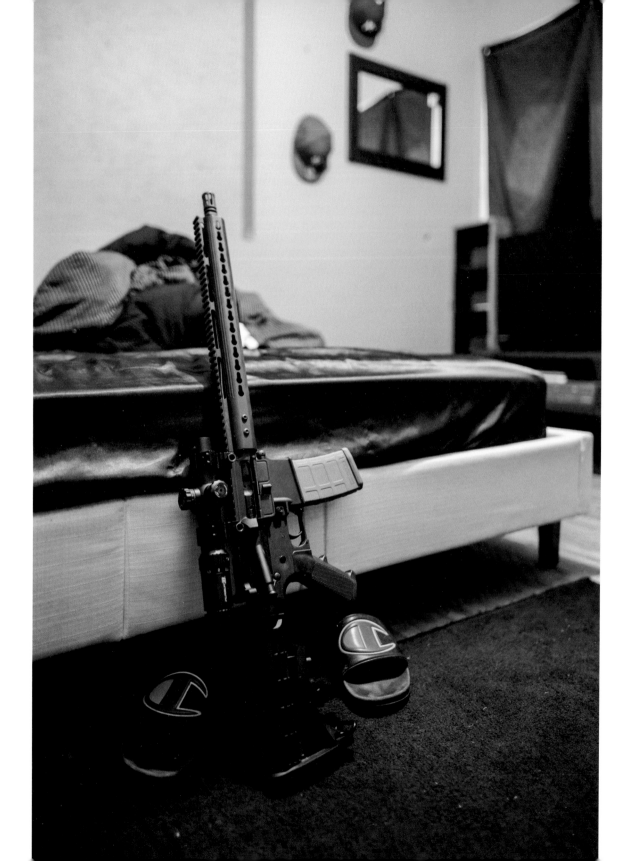

the poems wants you to look again.
look again if all you see is the cracked glass
like halos behind the lovers' heads.
again, the broken window policy.
allow us to remix: all that's cracked
isn't broken.
still you want to document.
to paper the background. to background check
the building.
nobody says gentrification around here.
that doesn't mean it doesn't exist, it means
we have different language. a different way
of seeing.
like when the couple kisses in front of the door
with the broken window,
you think juxtaposition.

when all we see is love kissing love in front of
love.

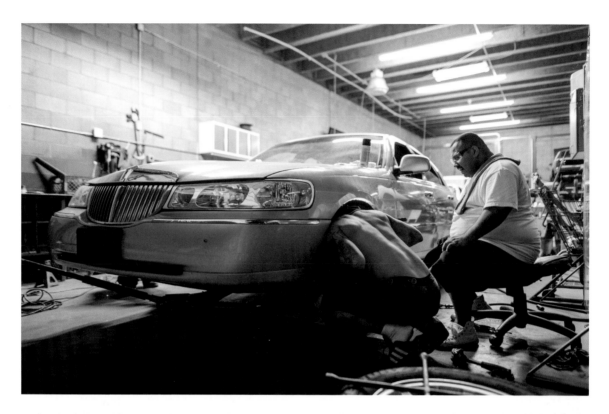

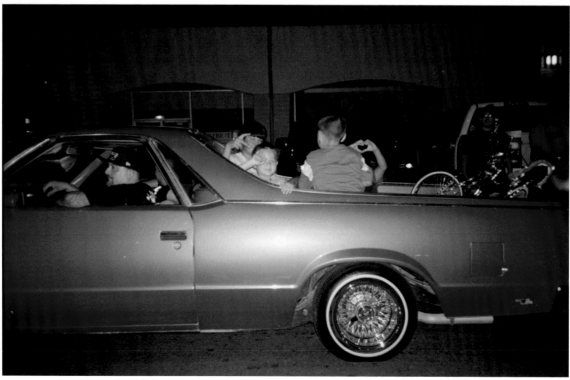

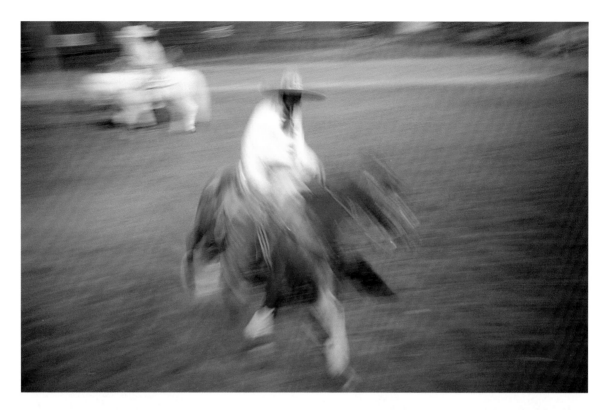

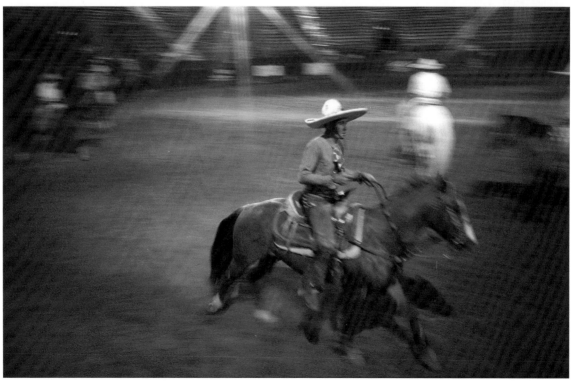

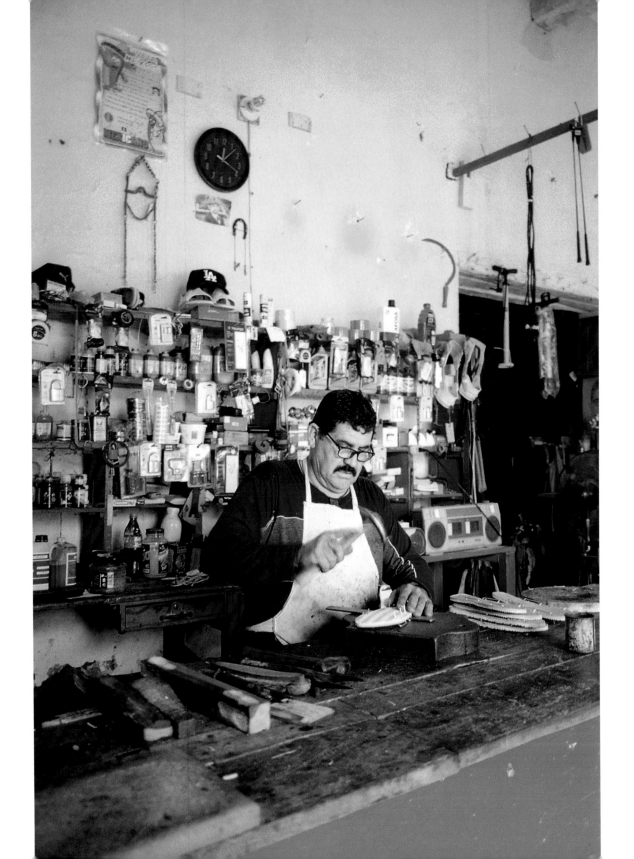

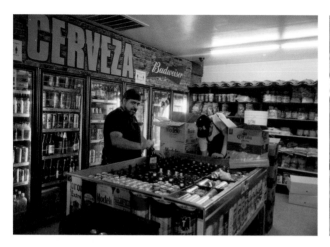

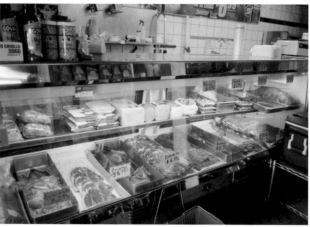

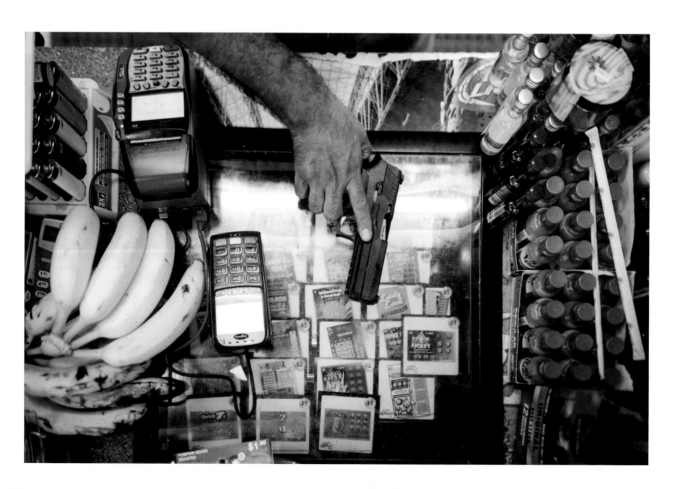

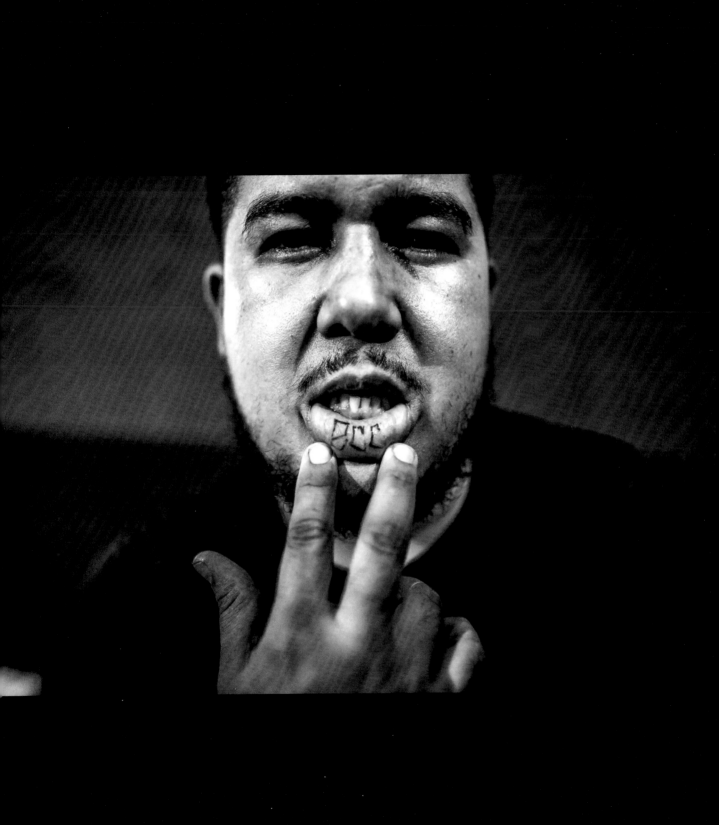

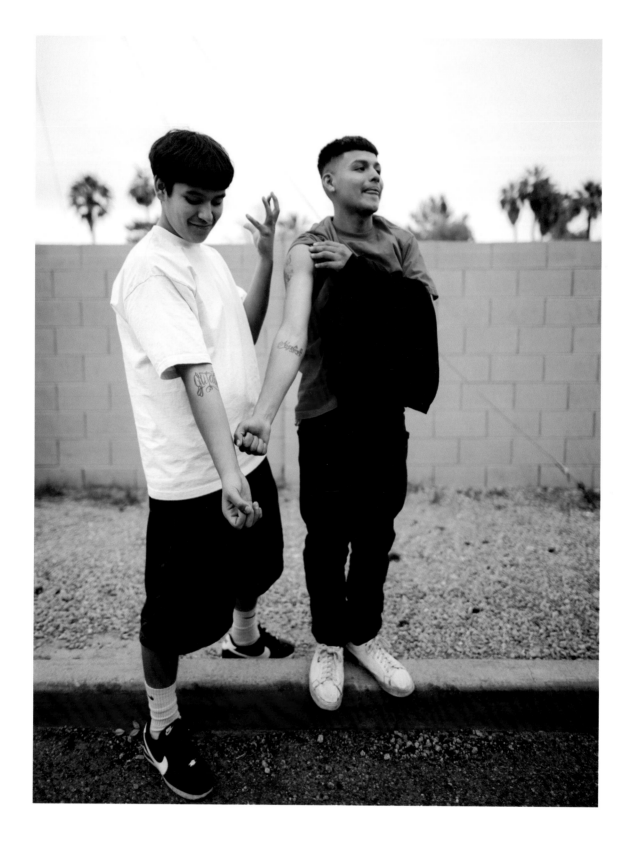

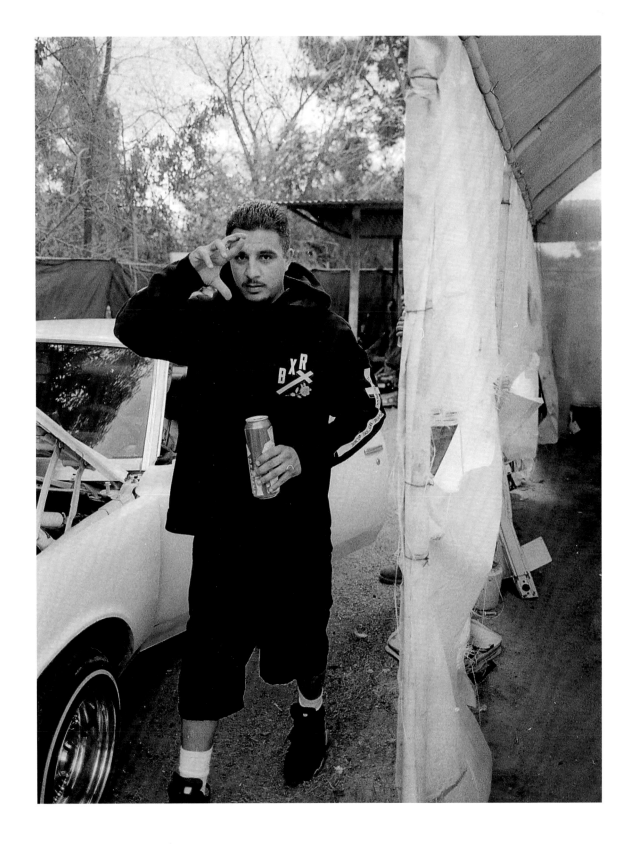

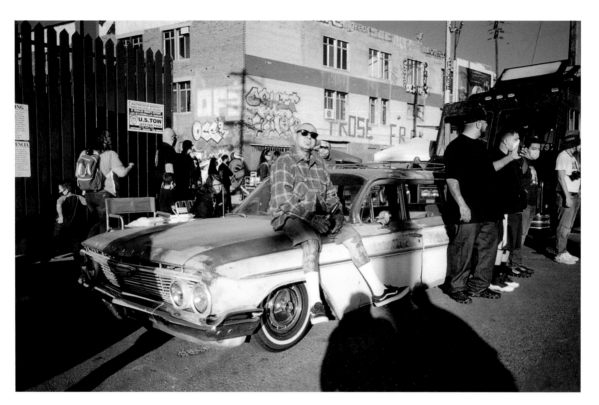

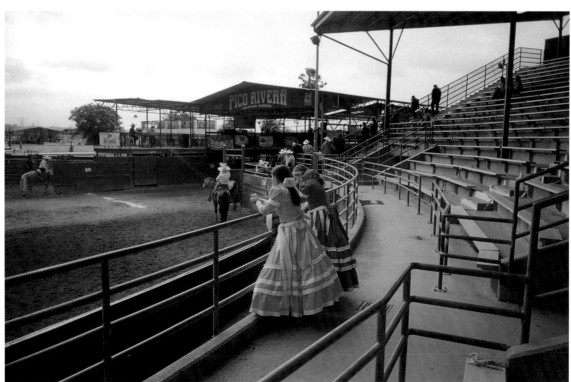

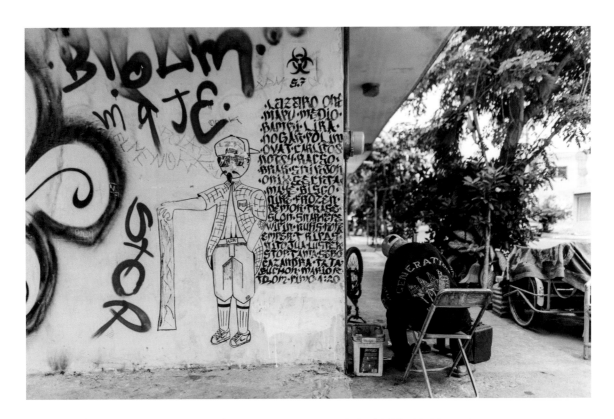

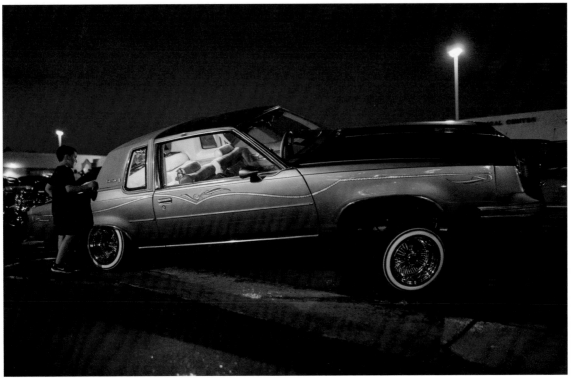

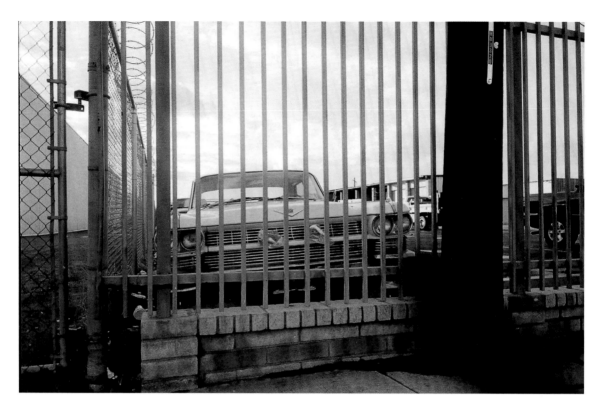

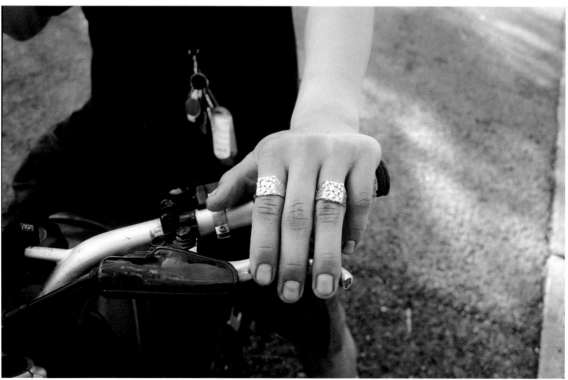

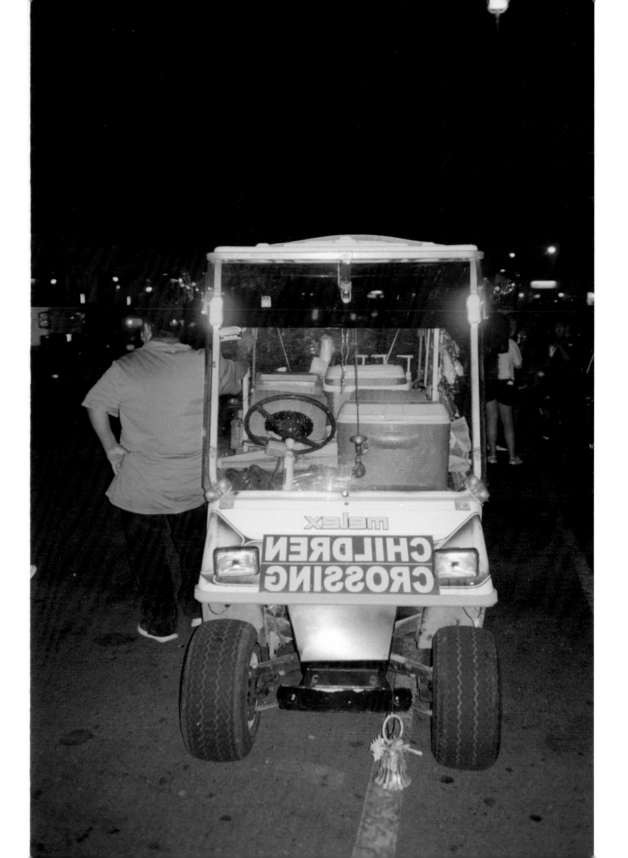

the poem wants no more art about cartels.

aren't you tired of the same Netflix plots? do Italians

get sick of Soprano reruns? the poem wants Mexican horror movies where the horror isn't a metaphor for the
 cartel.

El Chupacabra can't be an alias for a drug kingpin.

the poem wants to die of natural causes: something ordinary like diabetes or global warming. sorry to spoil
 the plot,

but every cartel show is about colonialism. off screen, American presidents clap at how their policies turn us
 Shakespearean.

the poem is tired of tracing stories back to Ronald Reagan, may he rest in piss. the poem was taught not
 speak ill of the dead, but the poem watched too many cartel shows

to honor that tradition. maybe the poem is sick of itself. every artwork unfolds according to the
 wound

of the beholder. the poem knows there's only two shades of green in the entire world: the green of
 american dollars and the green of green cards. maybe

americans love cartel shows because they haven't learned the names of their own monsters
 haunting daylight.

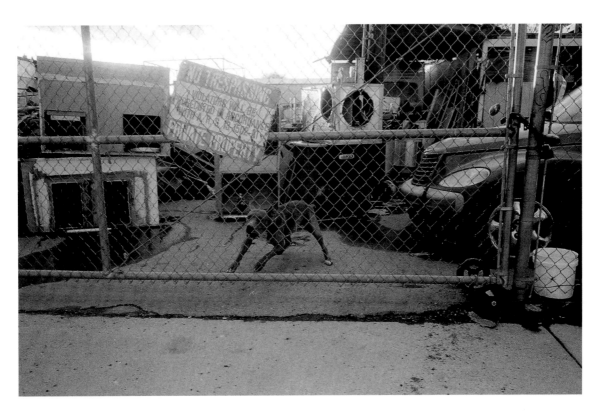

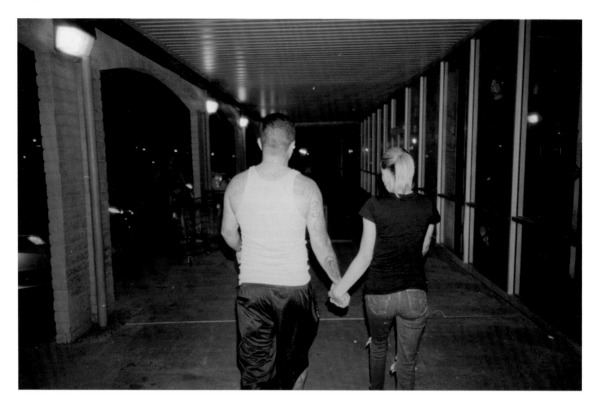

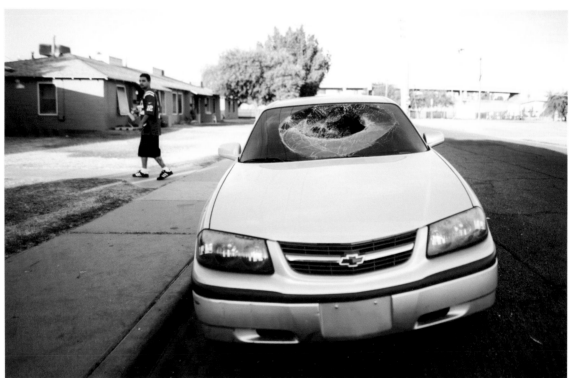

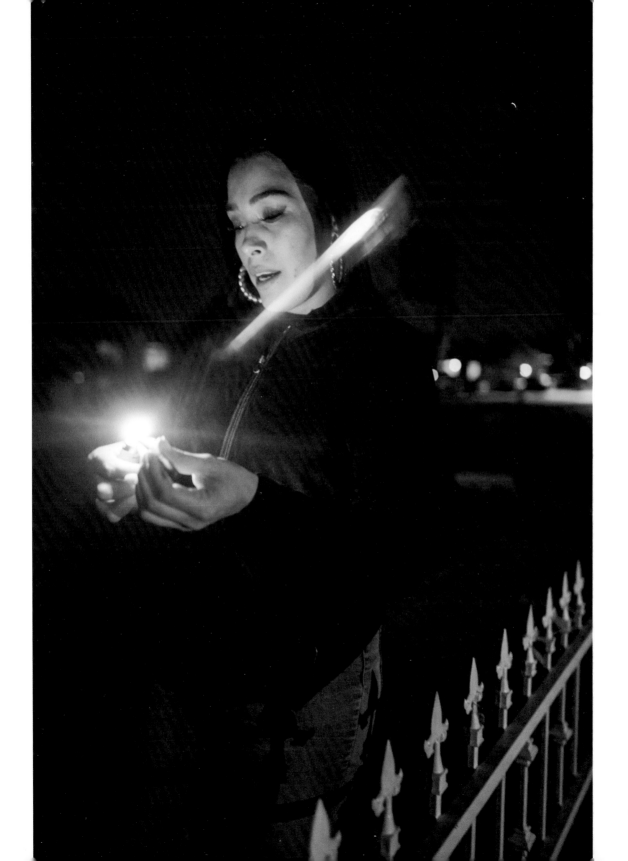

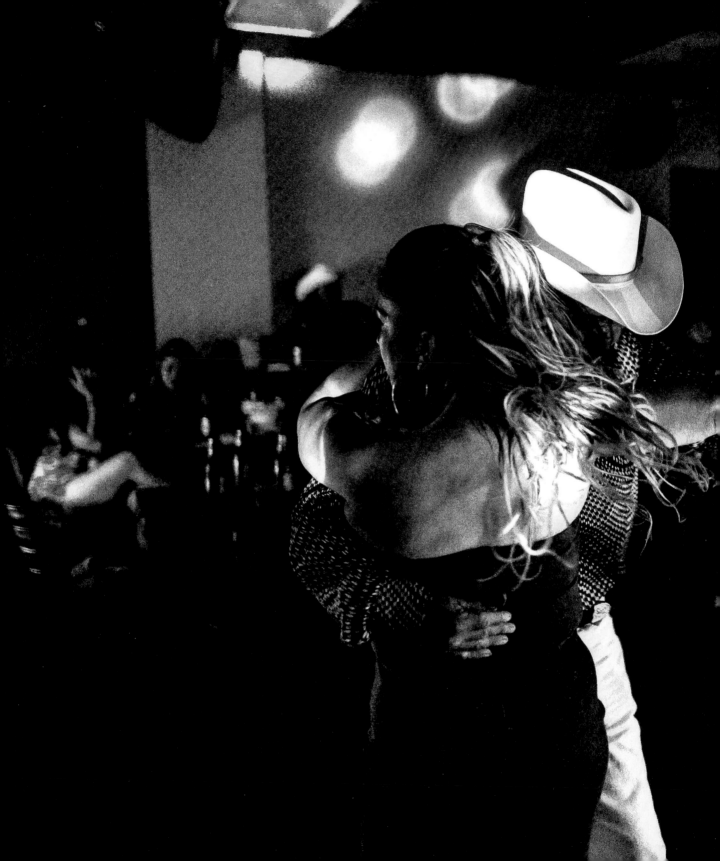

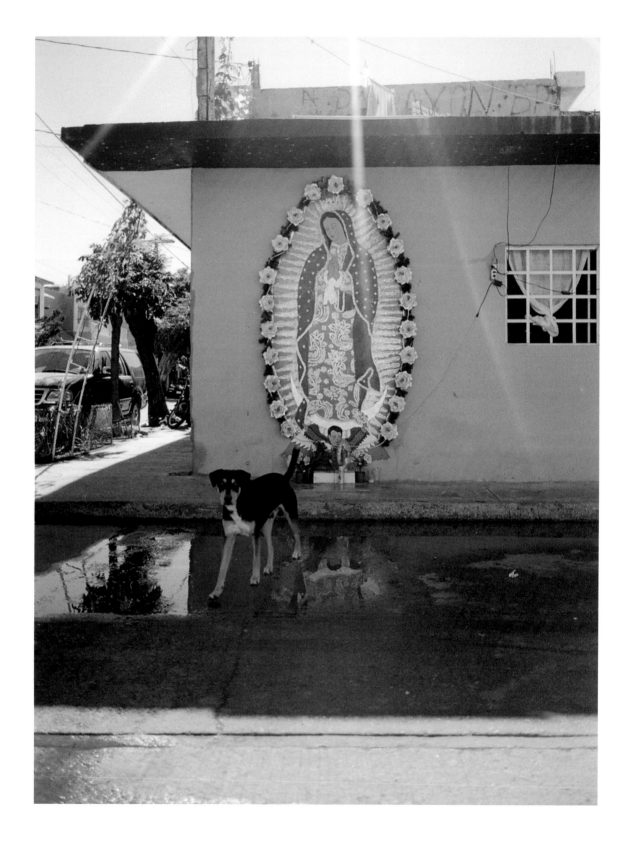

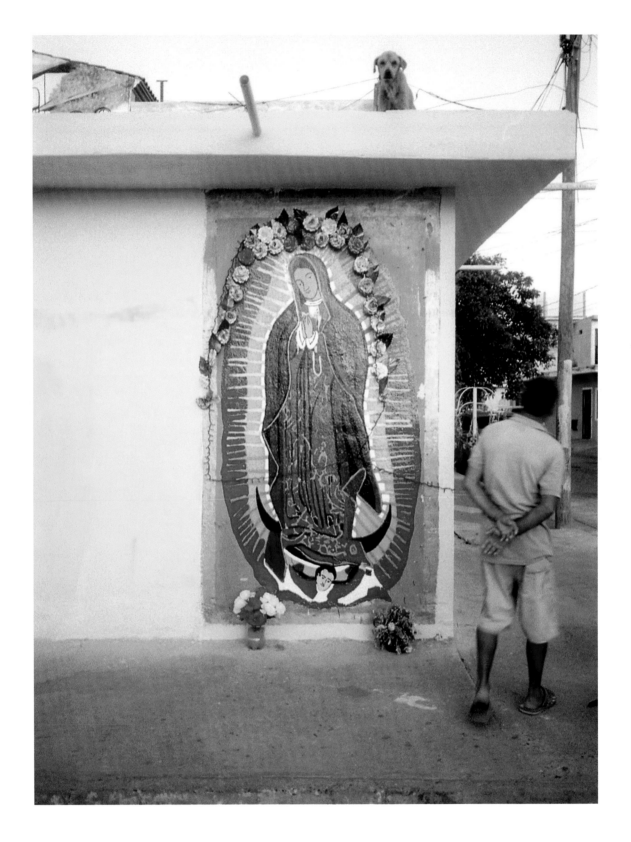

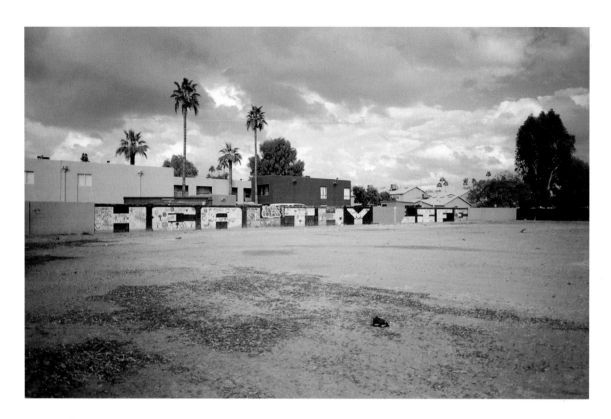

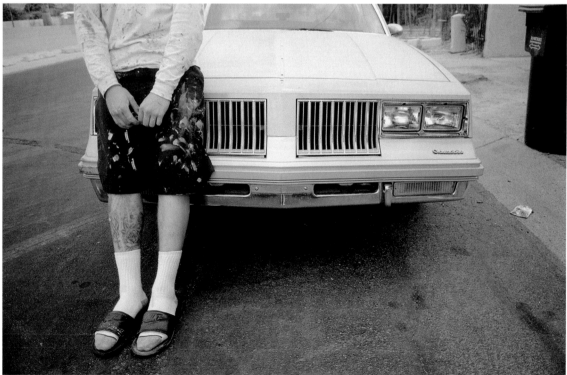

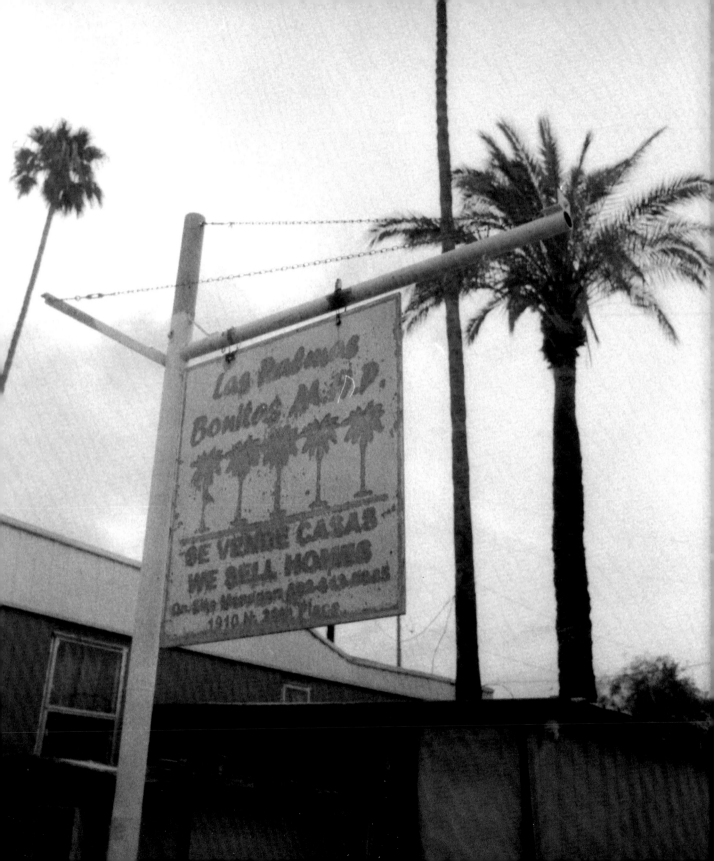

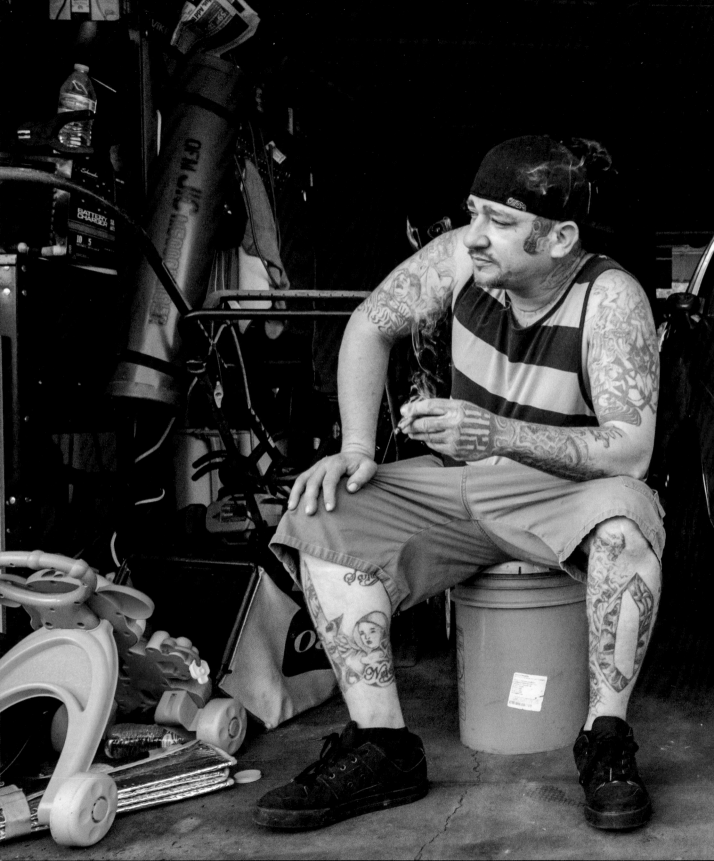

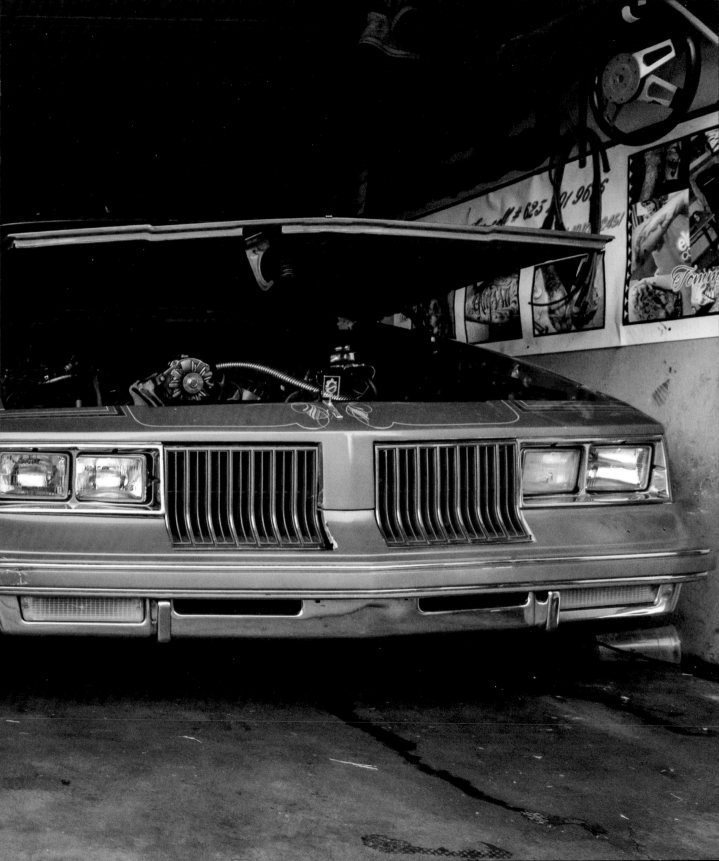

the poem wants. it desires. four boxing gloves
between the ropes. what would you do with two minutes
& the person who wronged you the most? unwrap
every wrong until it shines in the light. like plucked flowers,
most tough talk limps with time. the poem knows
something about anger. hold it too long & it poisons the holder.
can the same be said for love? digestion turns all tasty treats
into the same shit. dead flowers attract gnats.
even misery is a show. the poem desires an audience.
a right hook to the temple will cure you
of whatever ailment you're holding onto. it's hard
to hold a grudge from the ground. when we suffer,
we want a witness. the secret to taking a punch
is to accept it. the curse of being human is no matter
how much love we get one day, we require more
love the next day.

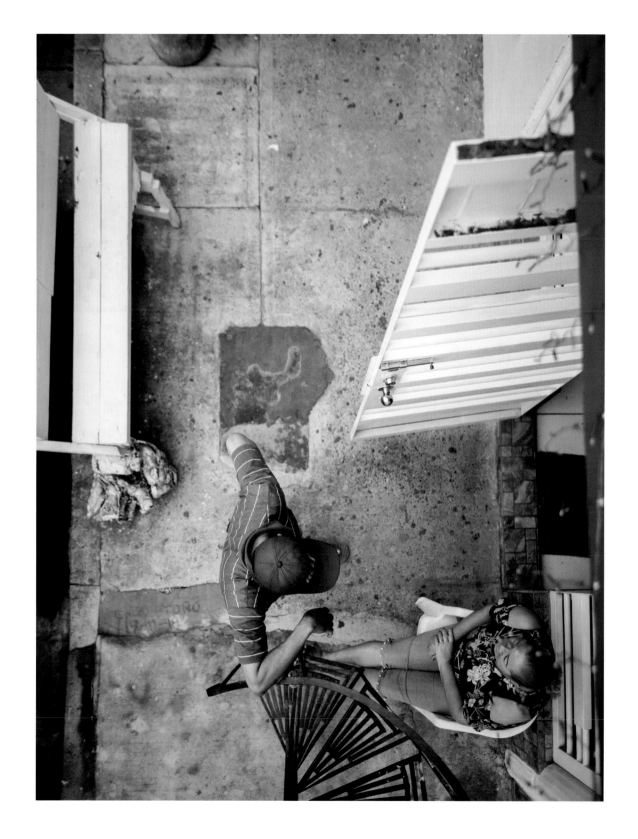

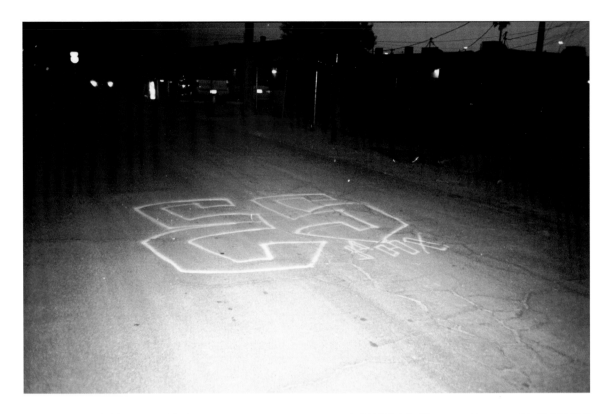

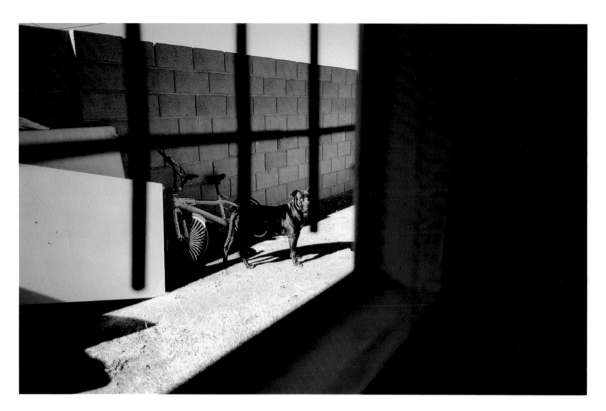

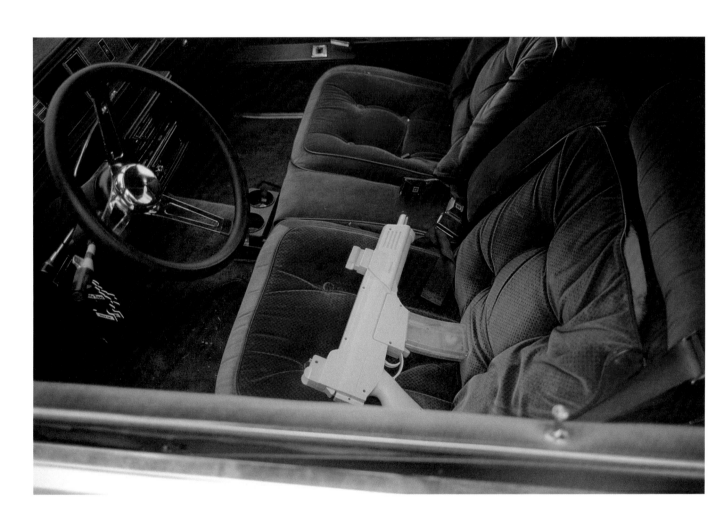

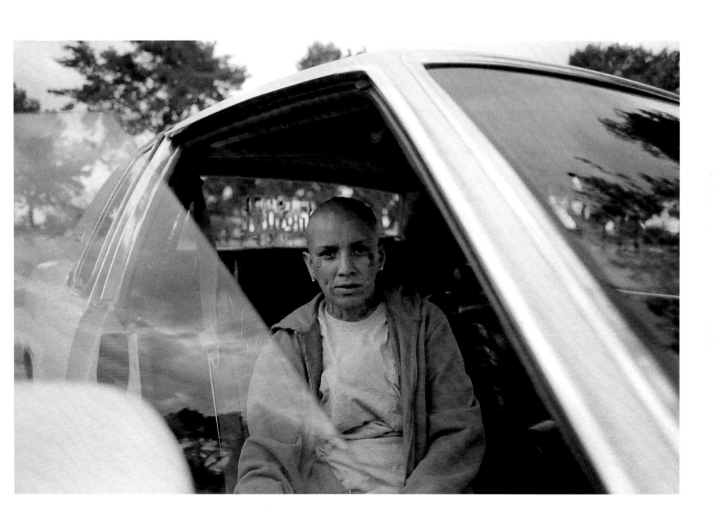

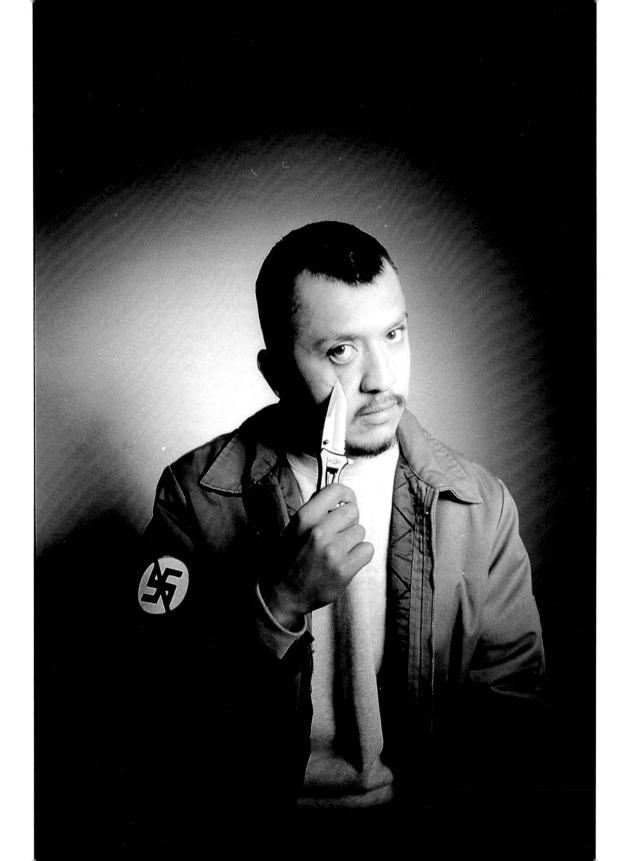

the poem is tired of art that doesn't bounce. SUV art
 that leaves from one forgettable location and arrives nowhere in particular. the poem thinks destinations are
 overrated. better to cruise with the homies singing sad songs in Spanish.

better to ride around the same block over and over,
so everybody catches a look: the car so clean you could eat off the hood. the homies blunted onto
another planet. the car sitting on two wheels so high it's a spaceship.

2.

Tradition

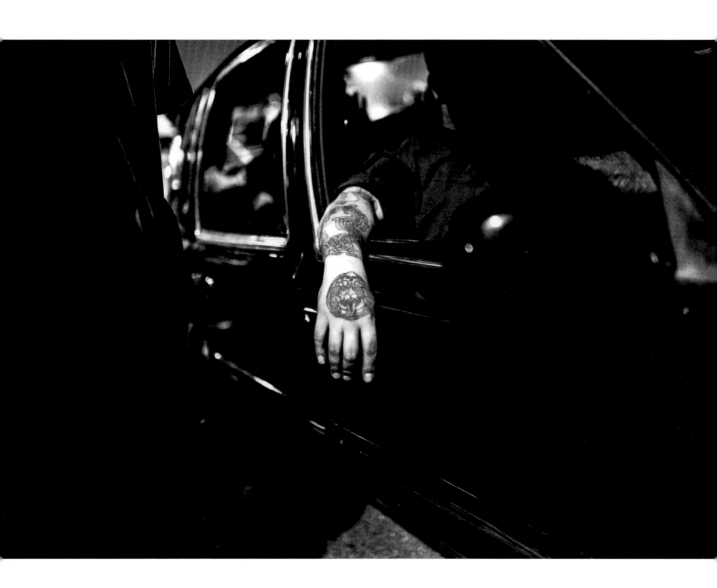

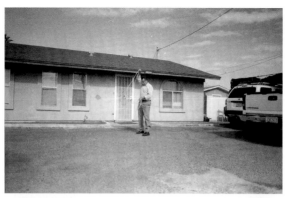

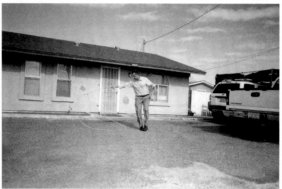

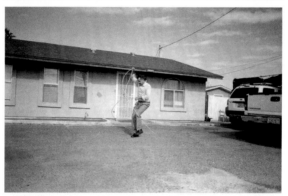

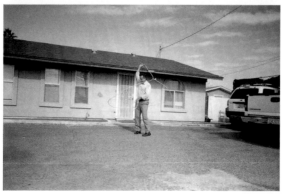

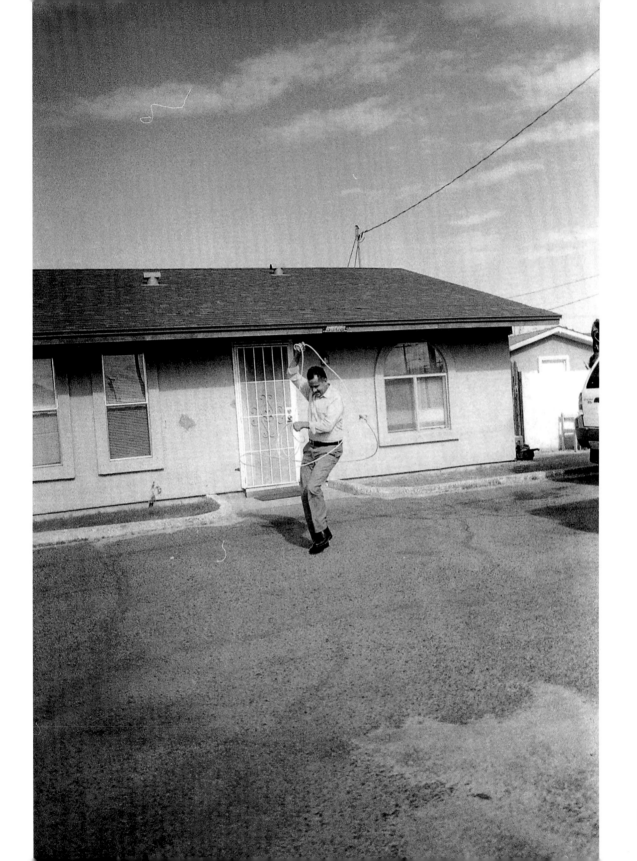

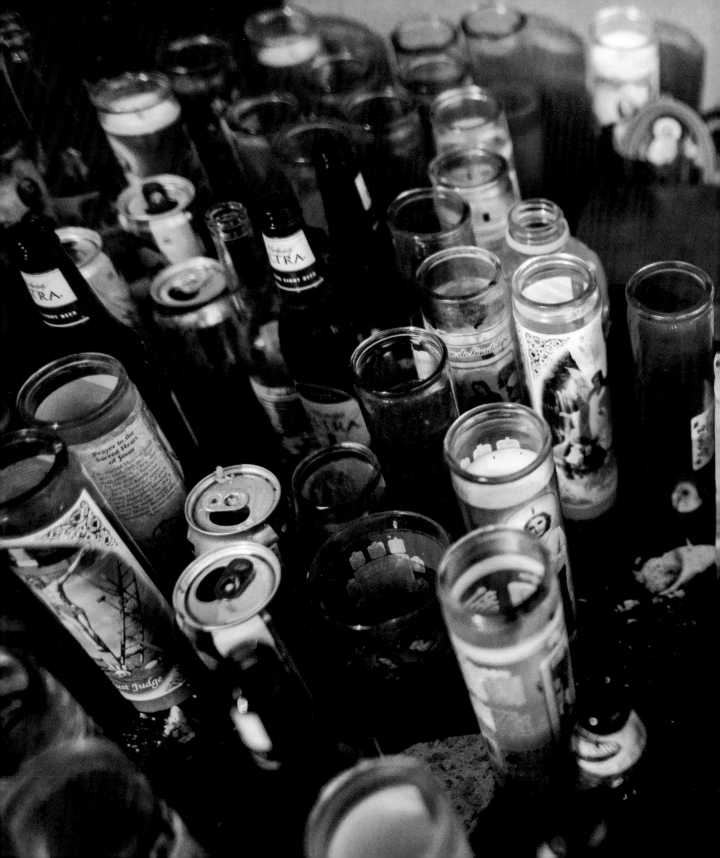

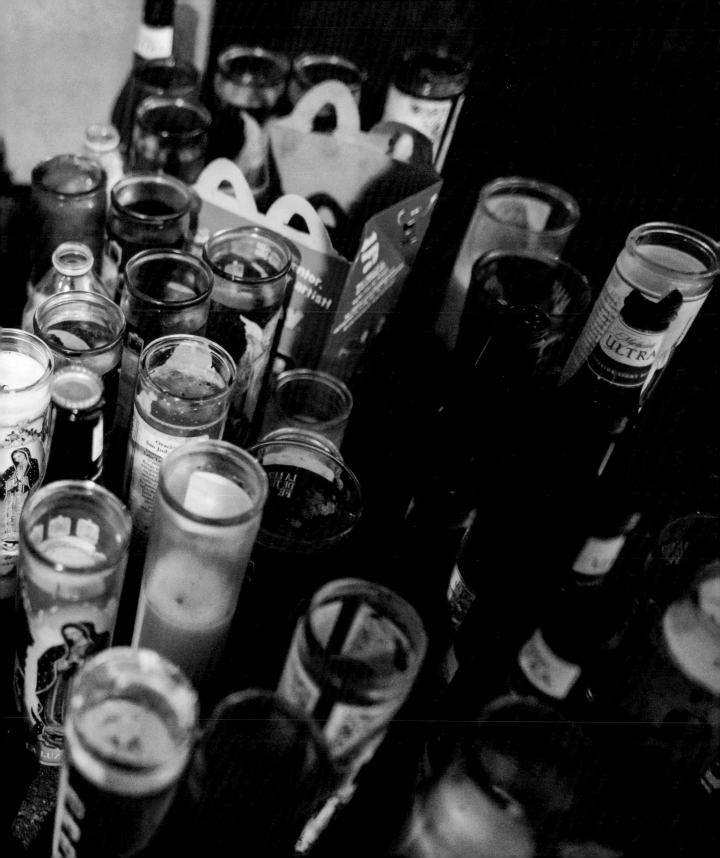

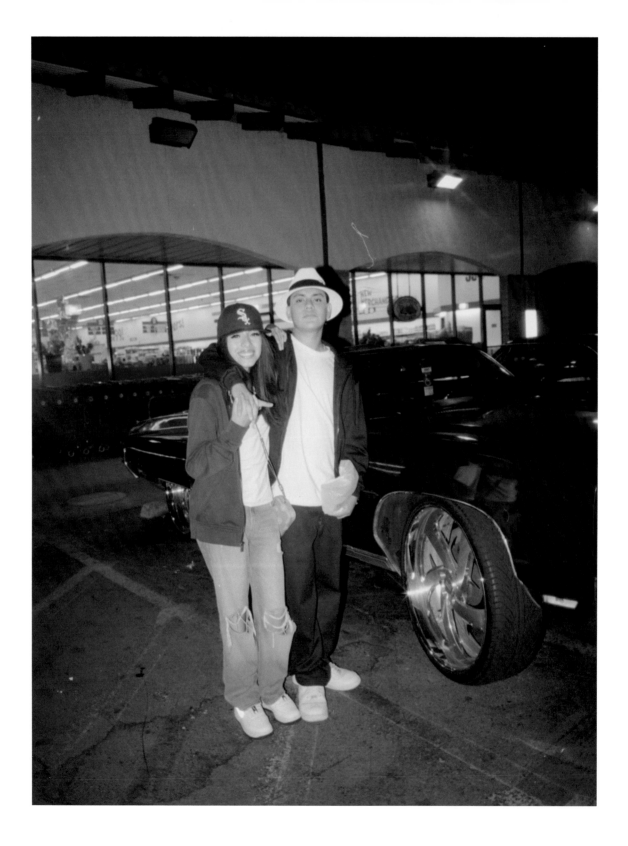

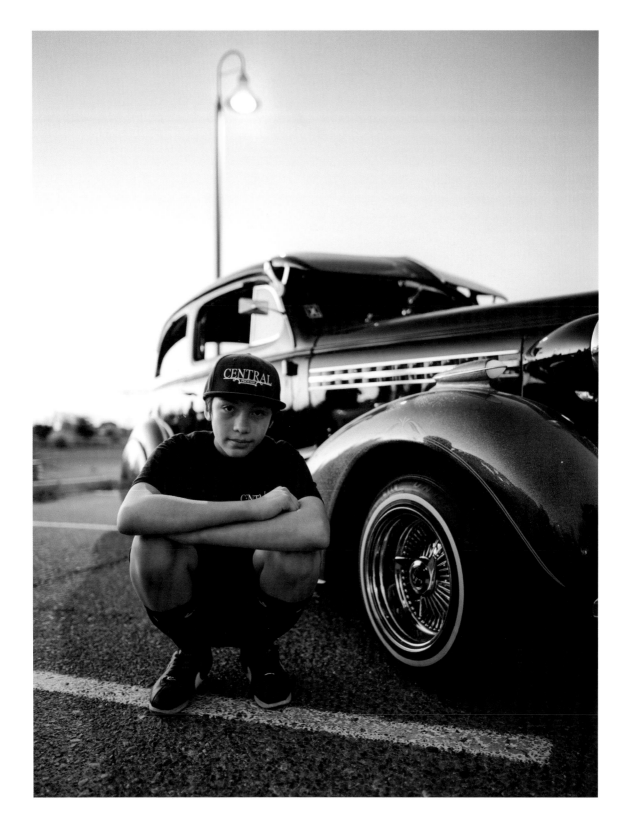

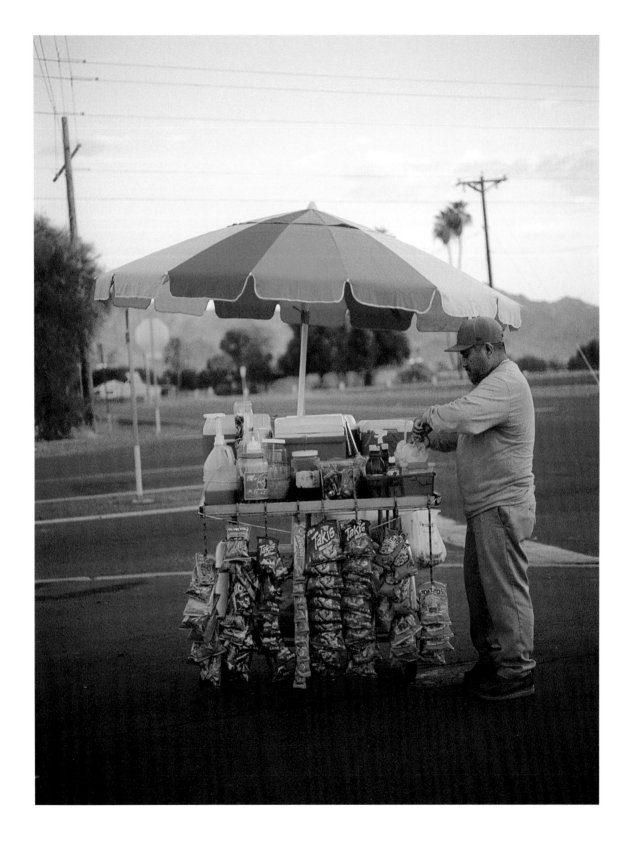

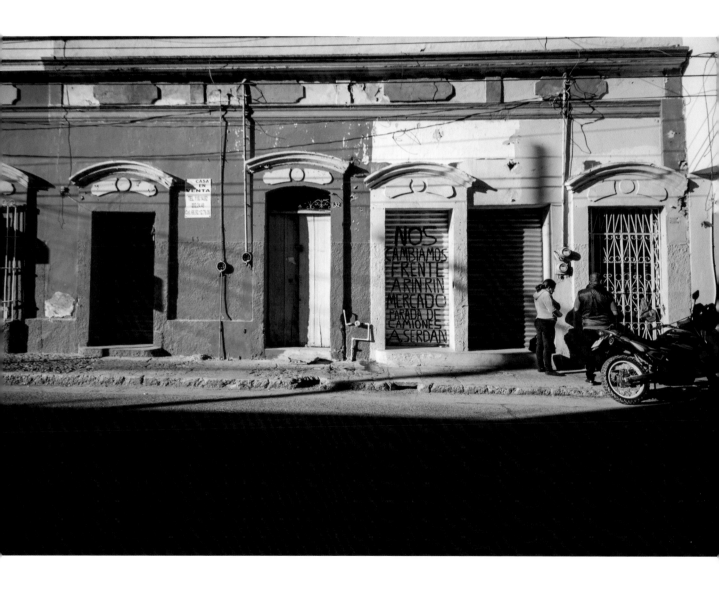

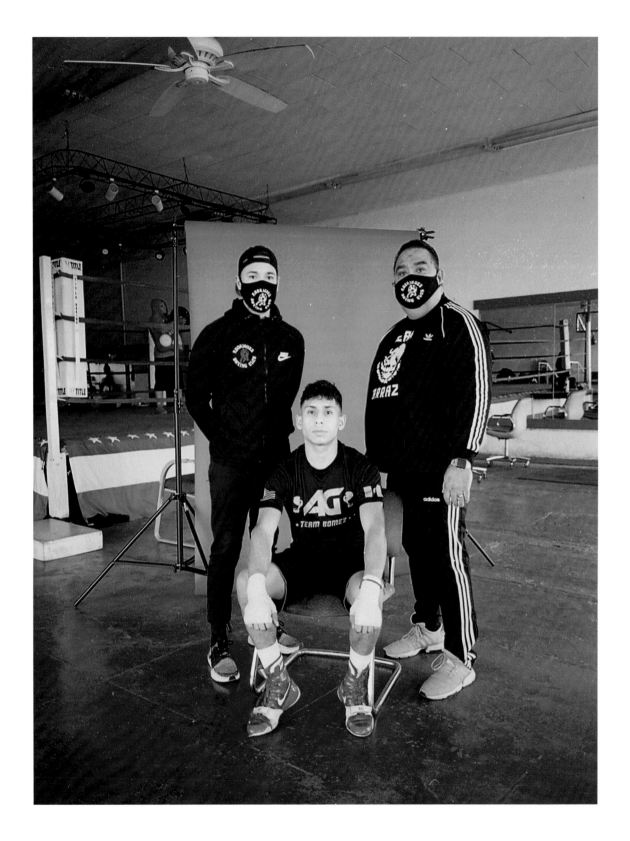

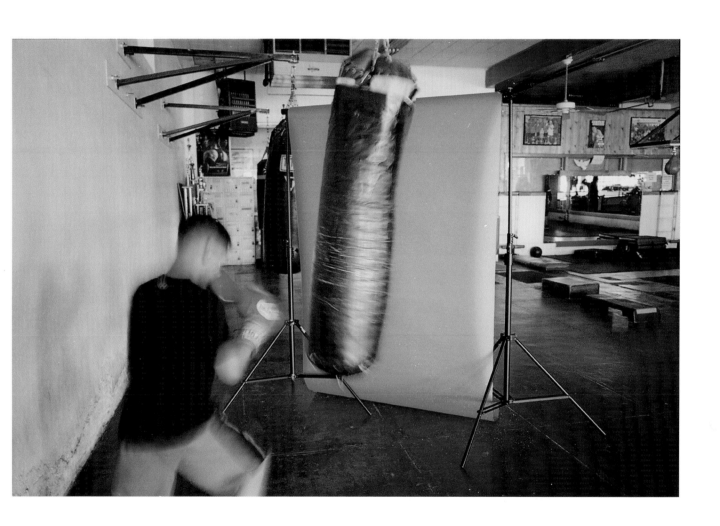

the poem doesn't want to hear about systemic oppression.
the poem has names on its mind too. Monche
with diabetes & no health insurance. what's the cost of insulin?
four sons gathering nickels. systemic oppression? is that the name
of a cheap insulin brand? four sons holding snow in their hands.
the poem knows Systemic Oppression—that foo used to date
Tia Lupita until she got pregnant. she keeps her daughter
& her Cutlass clean. even if she makes cheese
out of government powder, her daughter's belly never even purrs.
four sons skiing uphill. the poem never heard of systemic oppression,
but the poem knows price of death has been rising & the cost of living has been rising.
& someone is getting rich off insulin & is that oppression?
the poem only knows what Monche's sons say:
Monche's got the sweetest heart.

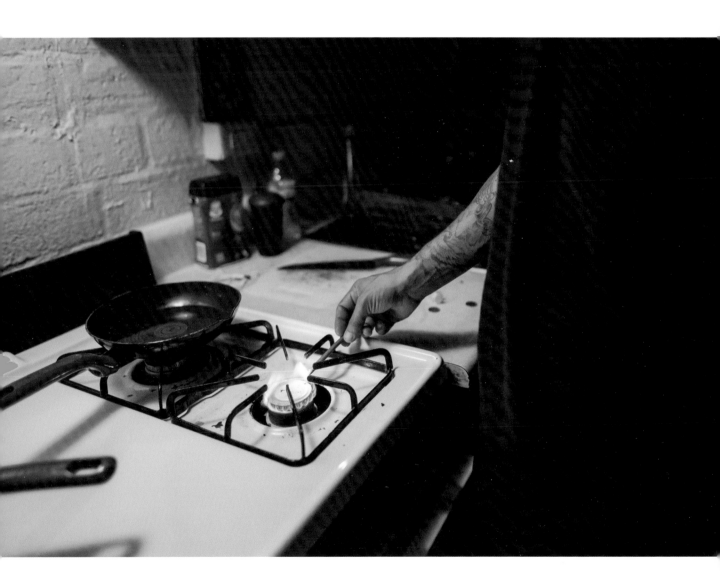

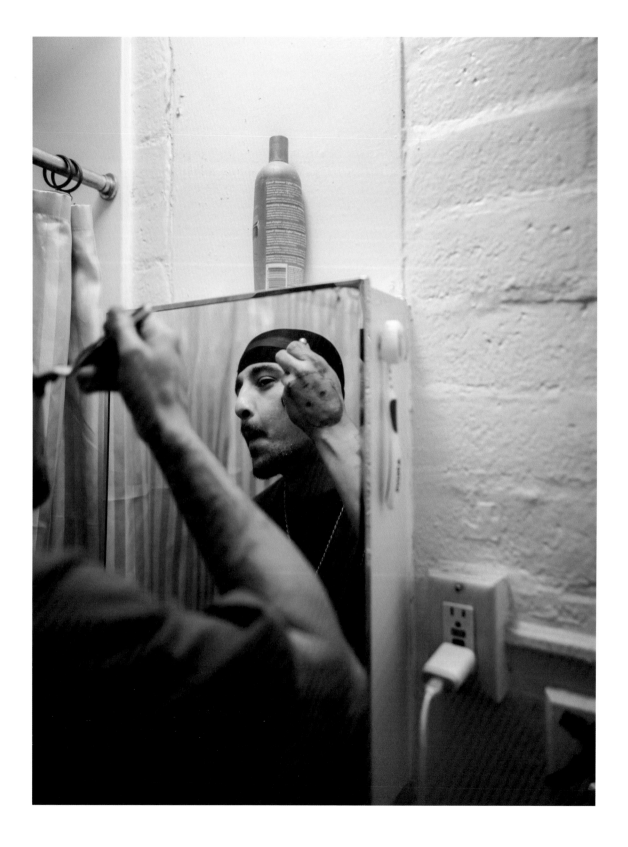

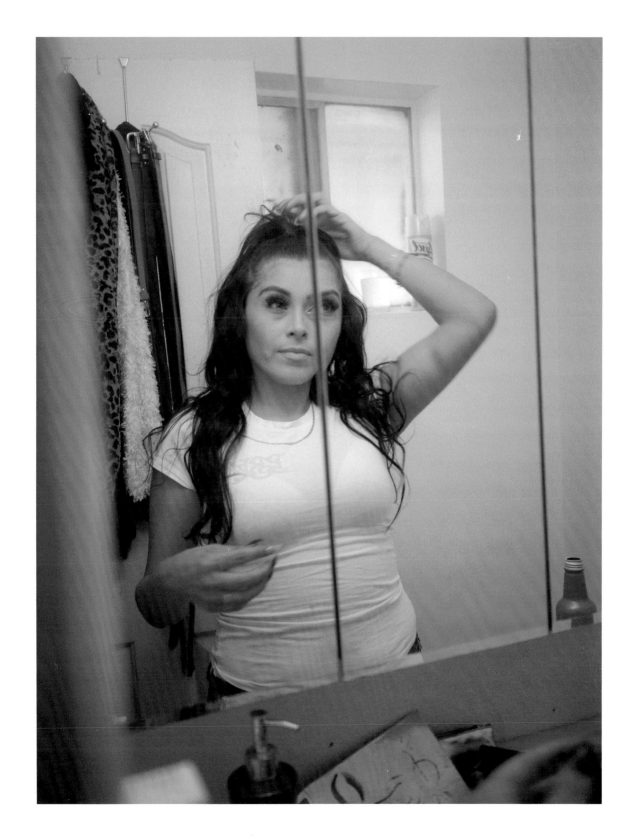

the poem wants to work. listen: growing up our parents hustled. they grinded. they worked
two jobs a day & two jobs after that. their reward: more work. never enough pay. or play. couldn't outwork
 debt. or death. dear god, it wasn't just sugar killing our parents. it wasn't just anxiety. the poem
is tired of working. enough of grinding. what does the huevón know? life is for living. apologies
for being obvious. we celebrate our parents for working themselves down to the bone, so we can work our-
 selves down to the bone, so someone else can get fat off our labor.
the poem is sorry for ever glamorizing the struggle. enough of work. enough of struggle. the poem refuses to
 be a good worker. the poem vows to never
be productive. huevón y flojo y qué? the only work the poem is interested in is working on a tan.
the only struggle the poem will glamorize is the struggle of cracking open a coconut without spilling any
 milk.

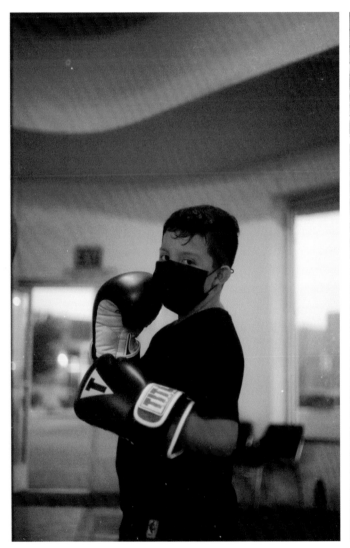

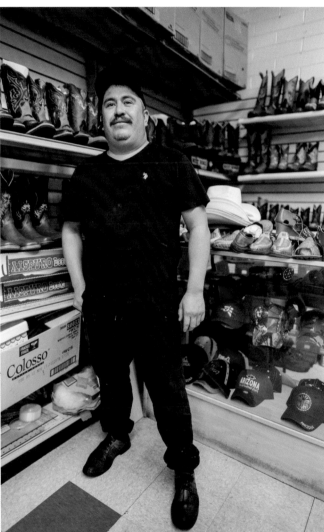

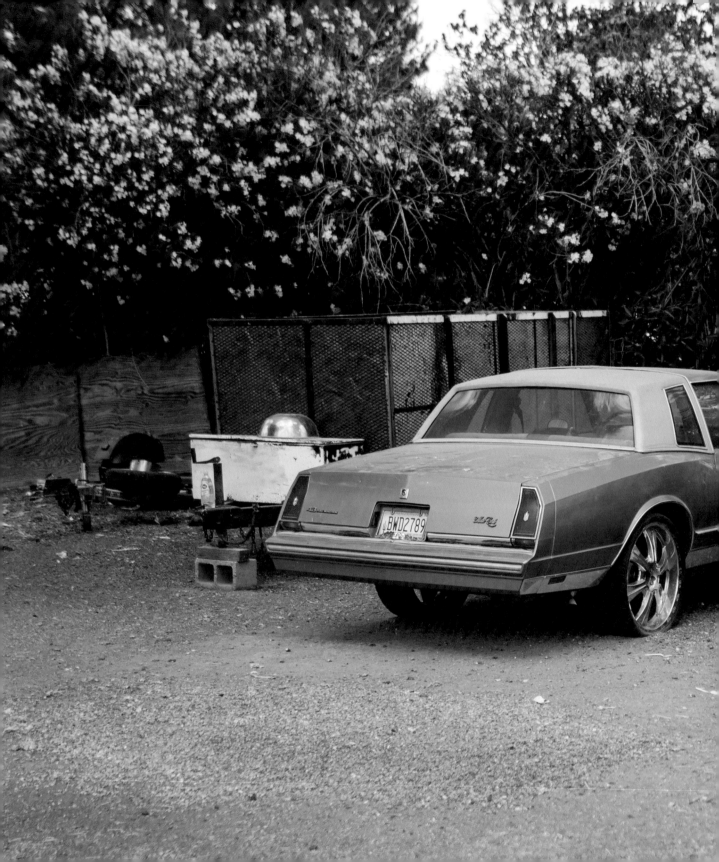

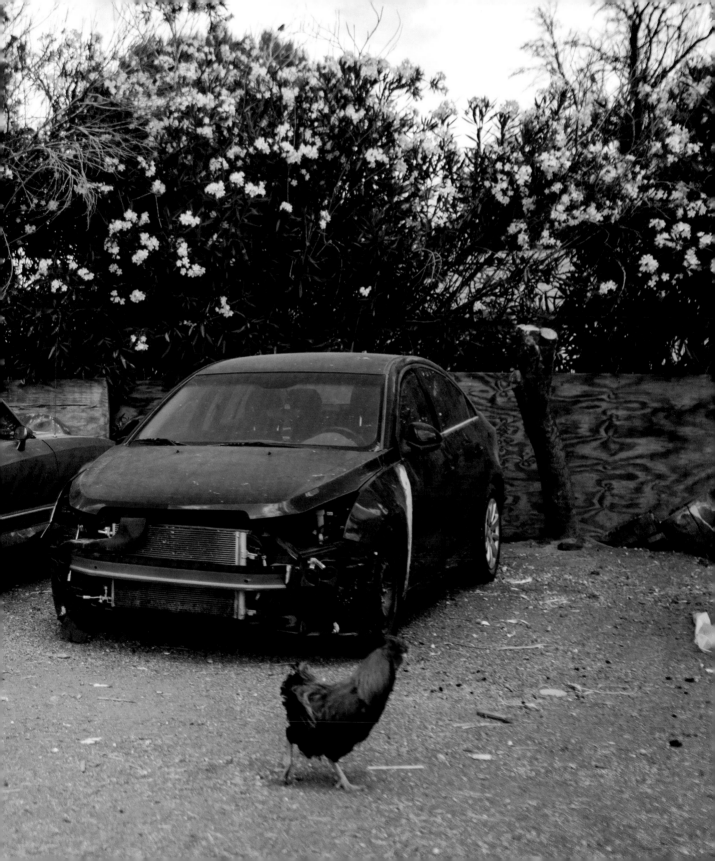

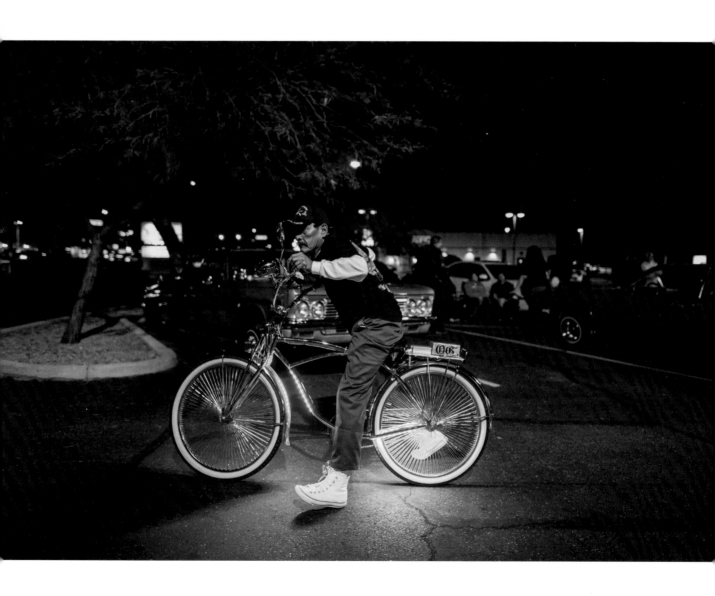

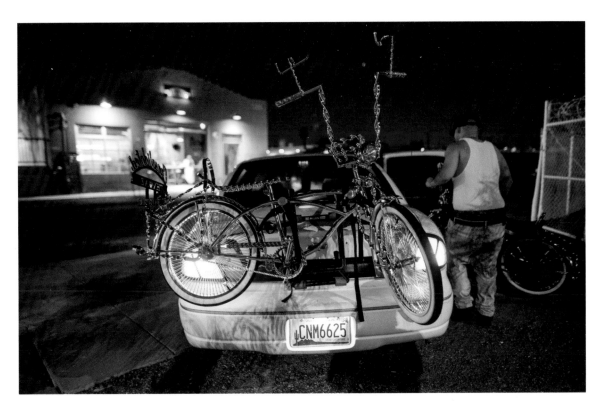

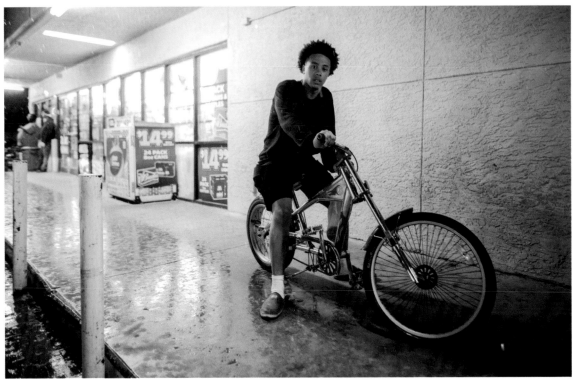

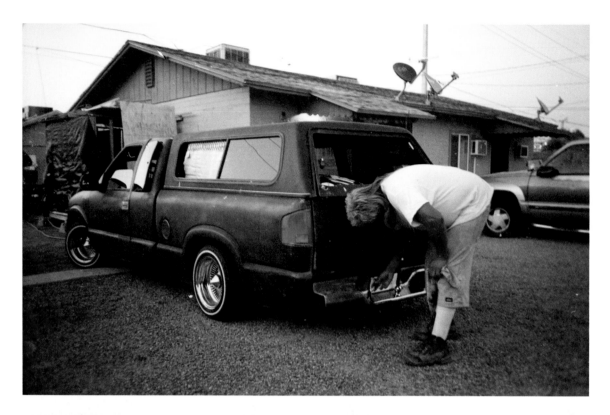

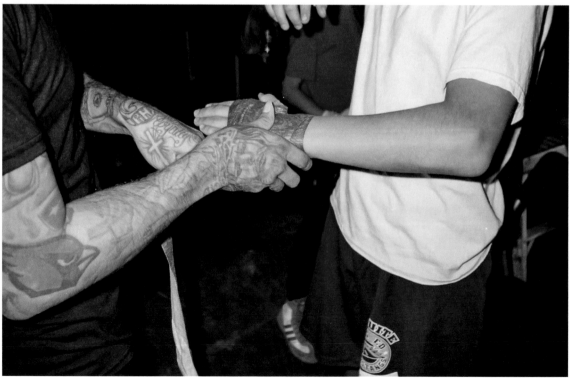

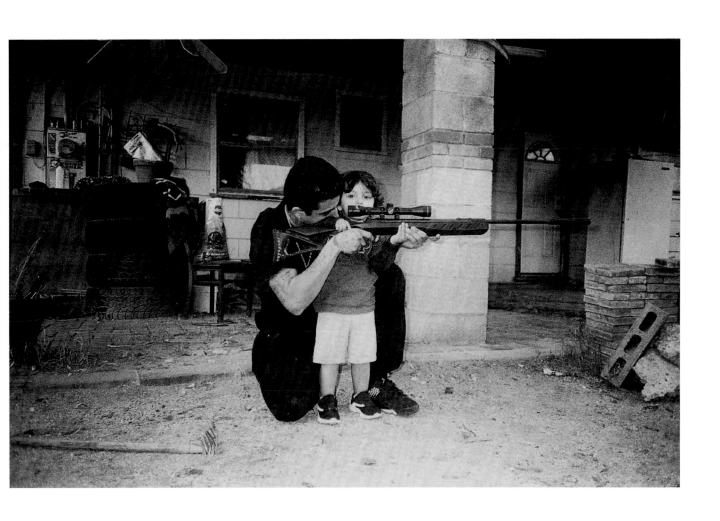

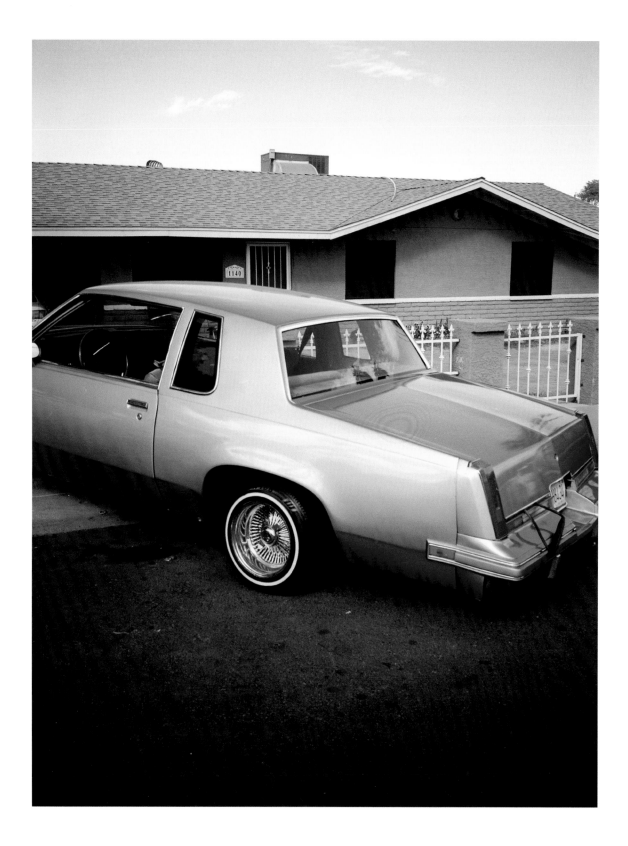

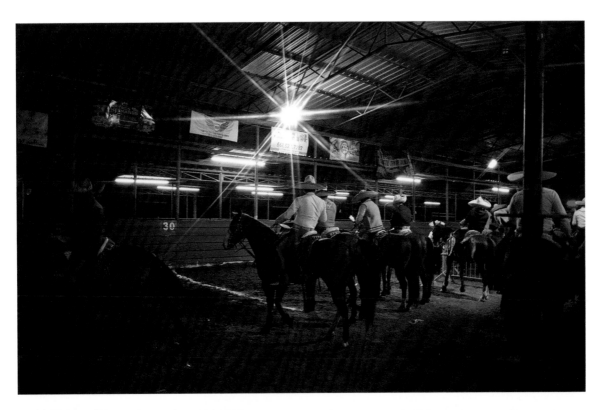

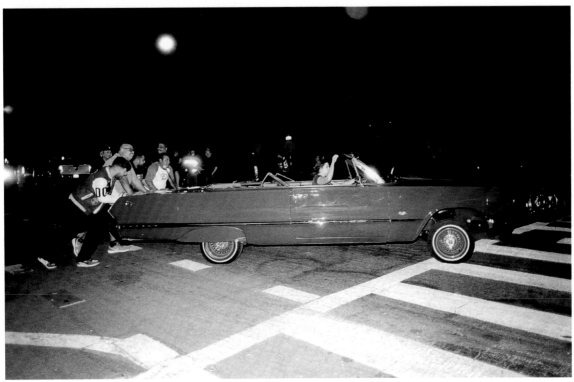

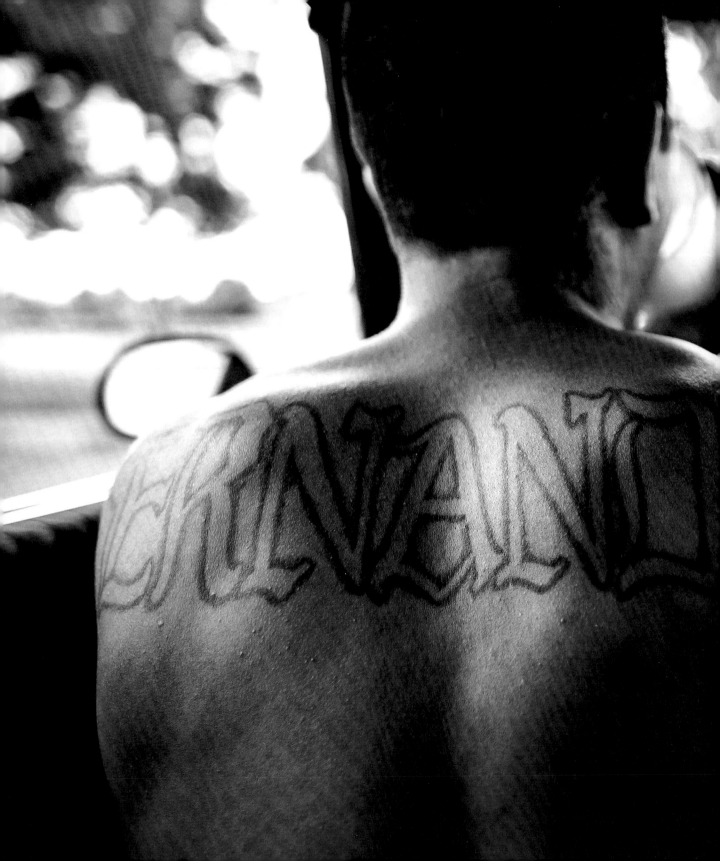

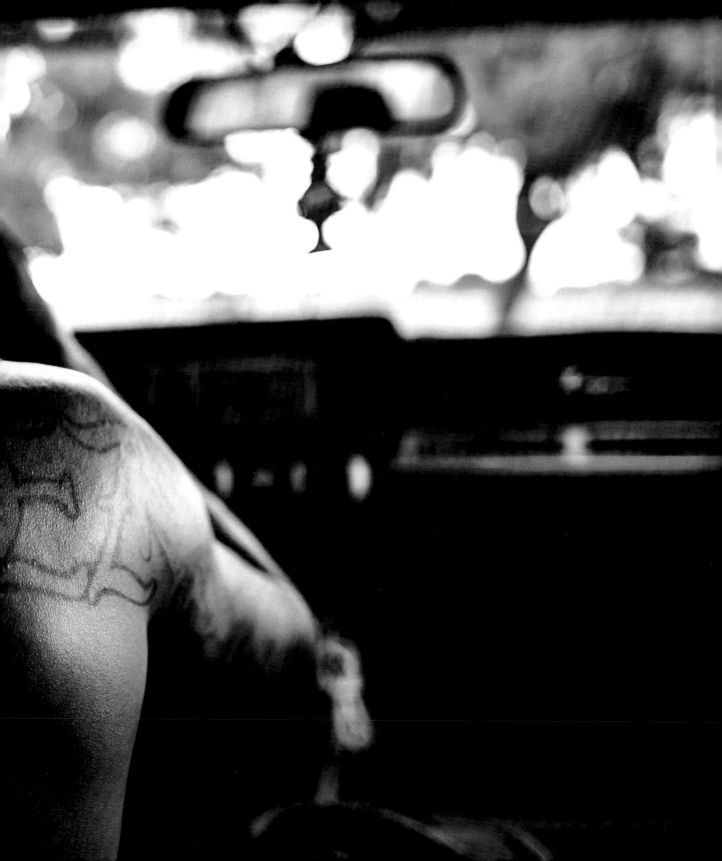

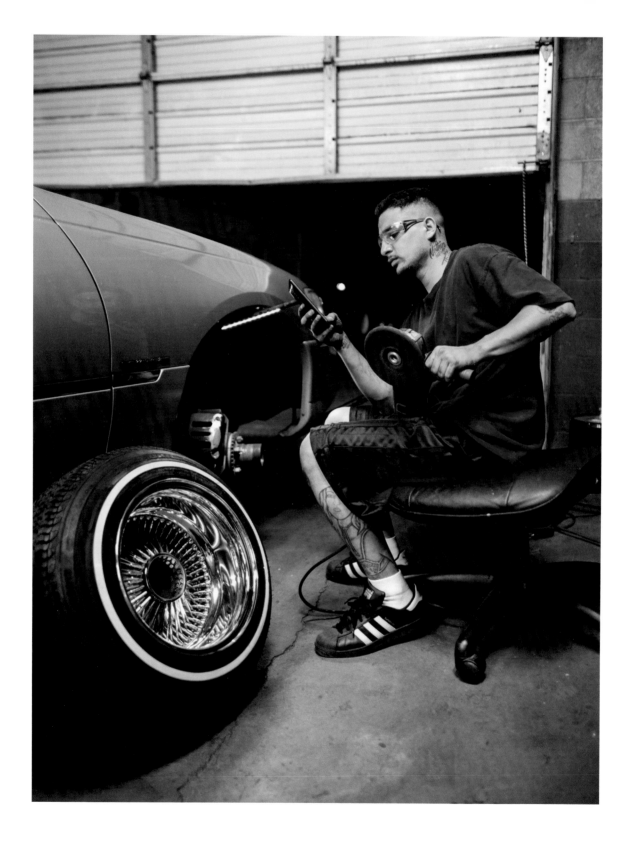

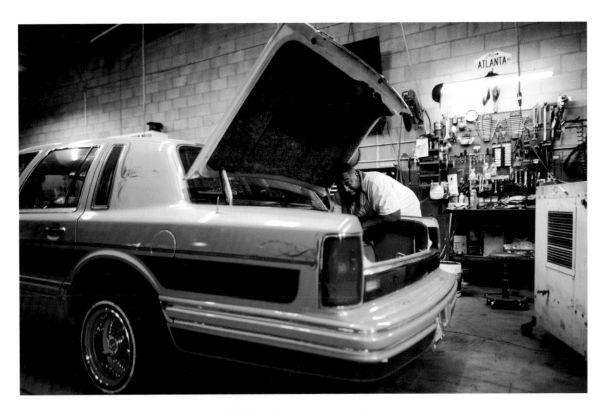

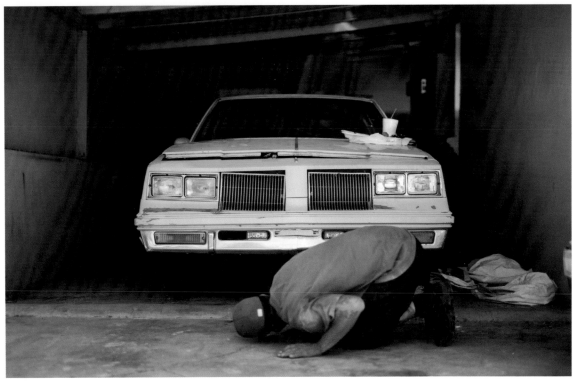

91

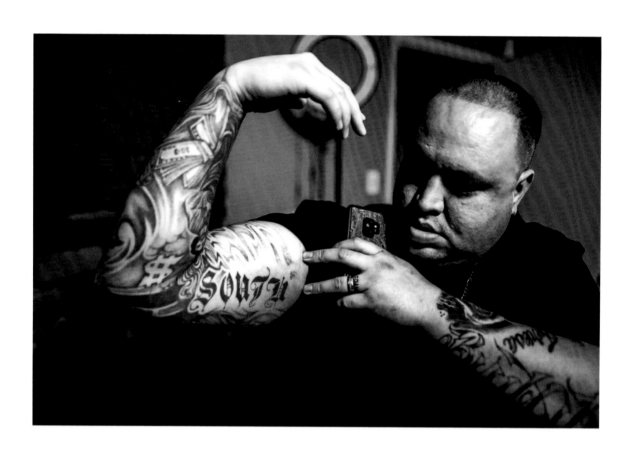

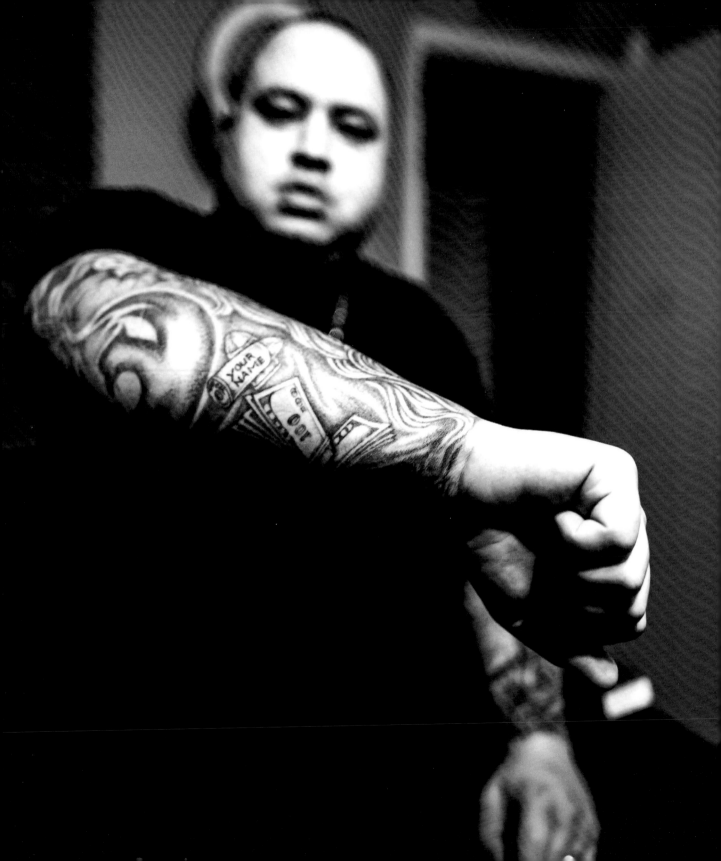

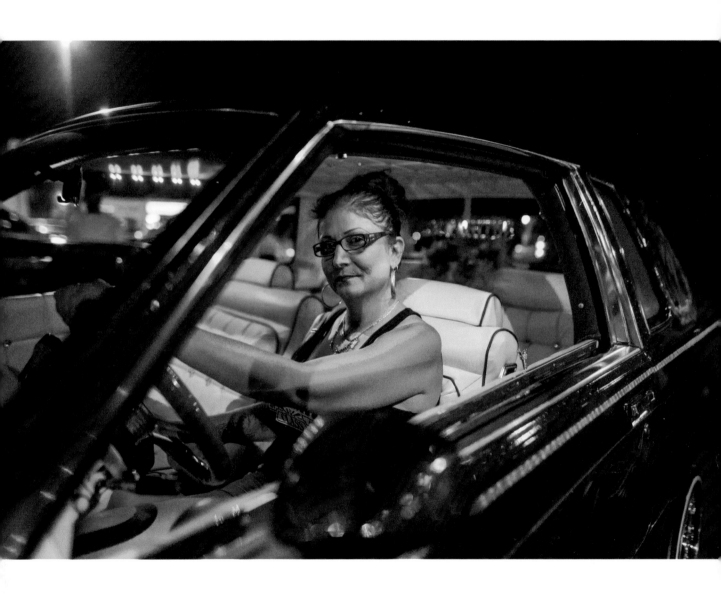

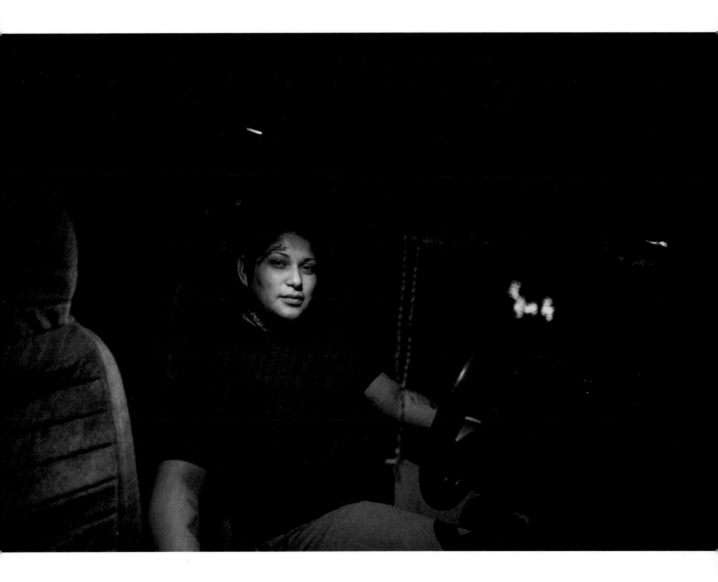

the poem wants to show off some new boots. in calumet city,
oscar once ran five blocks because he saw a kid get jumped
for their Jordans. remember when gym shoes started floating
from power lines? some of us touch like pit bulls,
some of us are tired of the same old leashes. we invent new ways to hang.
our hearts full of dogs foaming at the mouth. like every other animal raised by love
& made to earn its dinner. it's easy to dismiss violence
when the animal is ugly. & we are.
all our hearts hungry & ashamed to say for what.
oscar ran because he was wearing jordans
& there were jordans flying above his head like a movie poster.
the old heads like to judge the young, but don't be fooled.
 nothing gets to be pretty without teeth.

3.

Communion

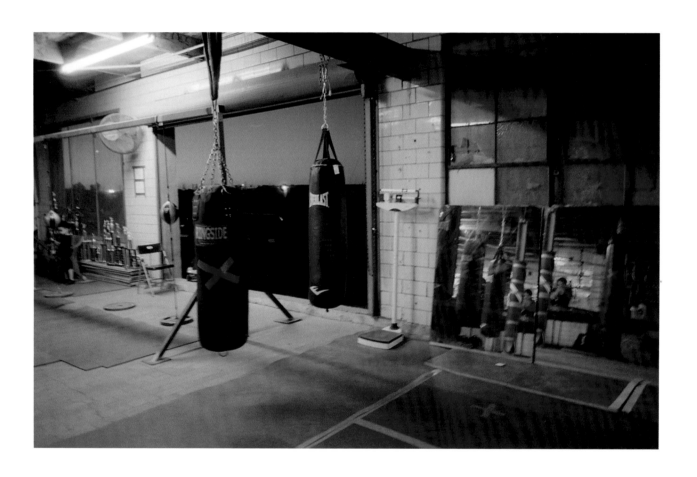

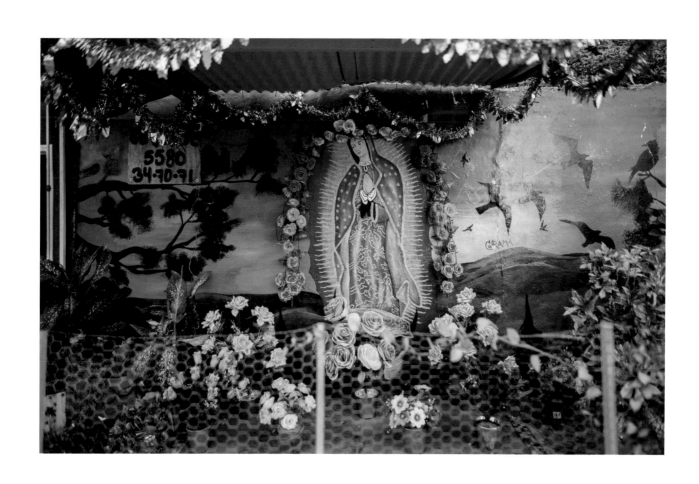

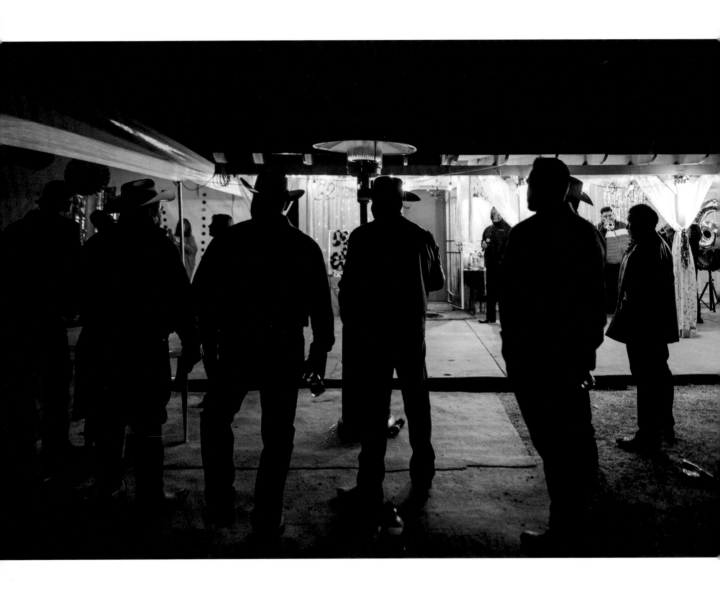

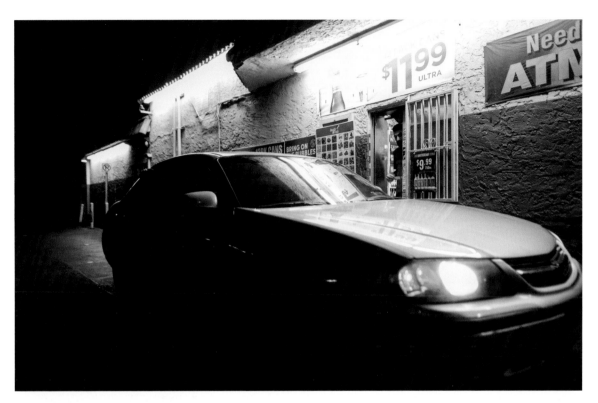

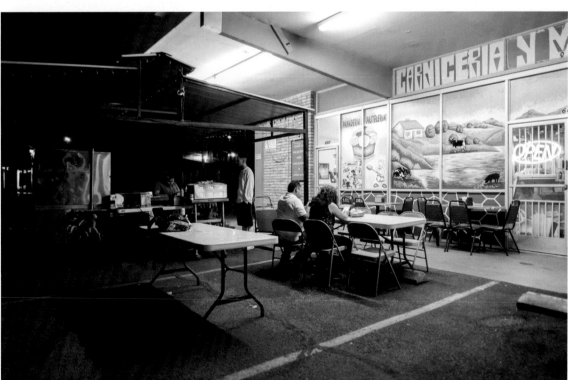

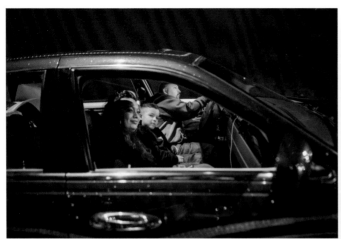

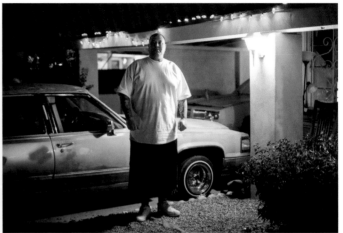

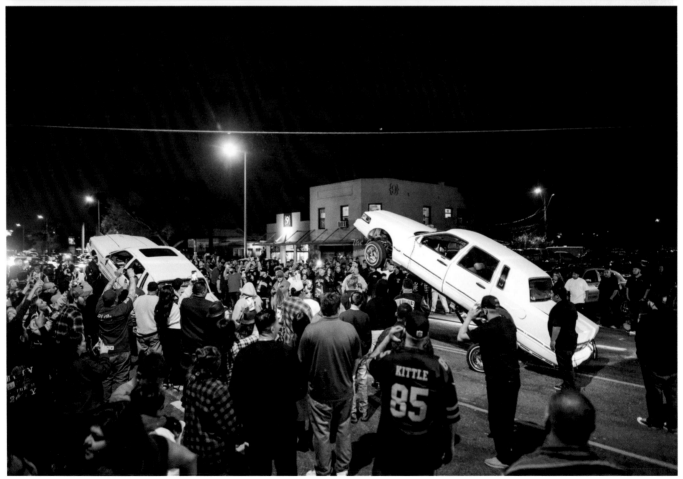

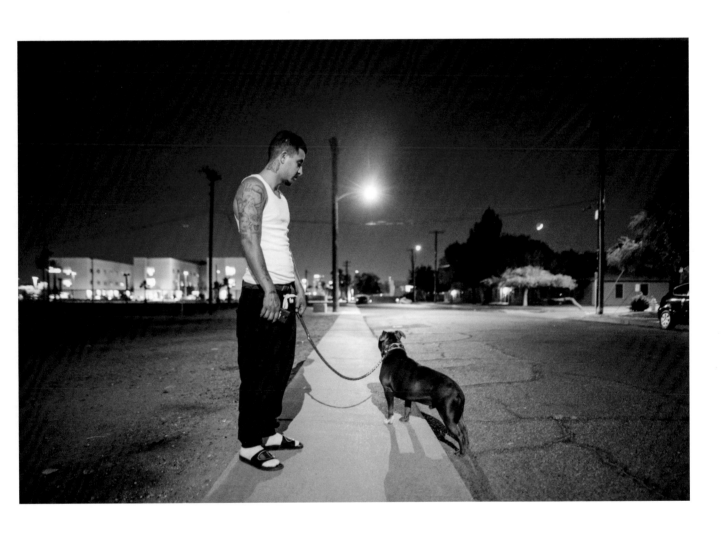

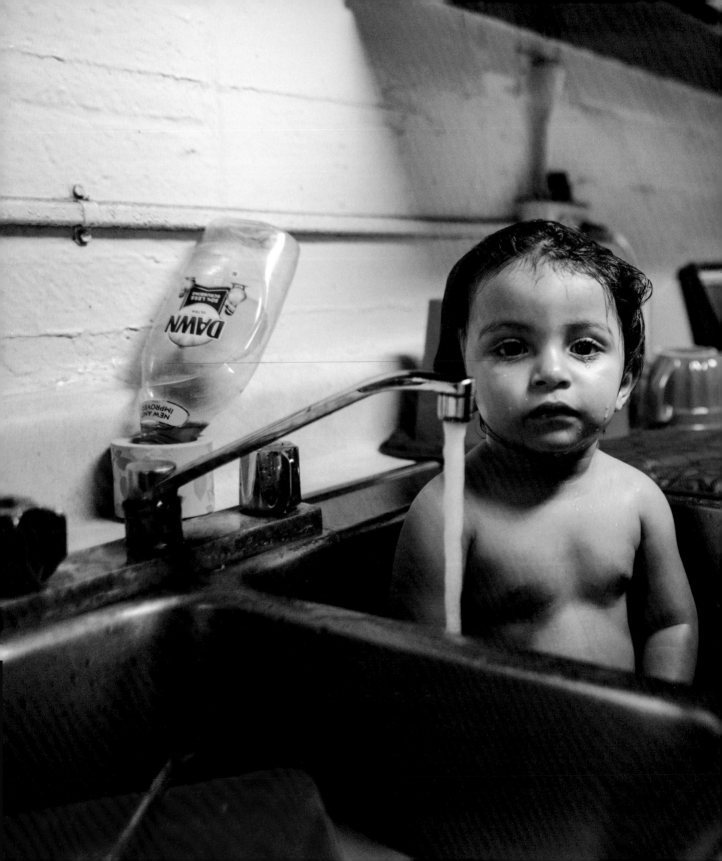

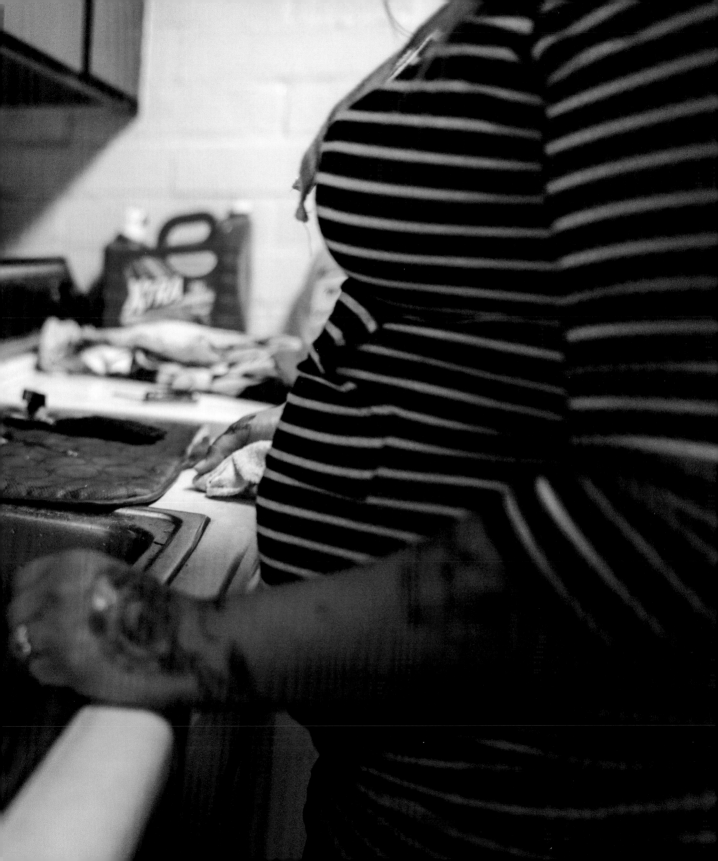

the poem wants to talk about love.
it knows you think love is corny.
but then again, the poem comes from maíz.
generations of gente de maíz surviving
(the photo doesn't want to say against all odds—
that kind of talk is corny) & how
do you think that happens? the poem can't define love,
but it can tell you about baby baths in sinks.
warm water poured on baby hairs. a baptism.
mothers & fathers with rent scratched
into their foreheads kissing baby cheeks.
birthday parties where the whole block shows up
& you don't know who's blood
& who showed up for the free beer.
the poem doesn't care about blood.
the poem doesn't know how to talk about love,
but it can show you.

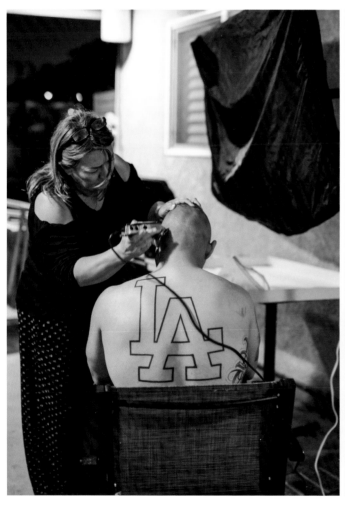
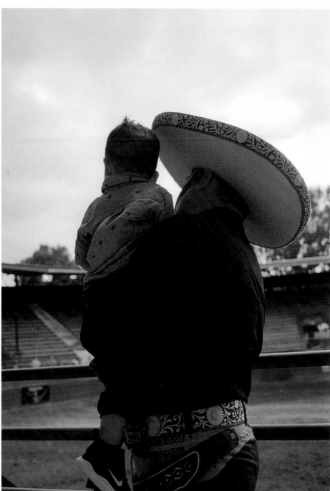

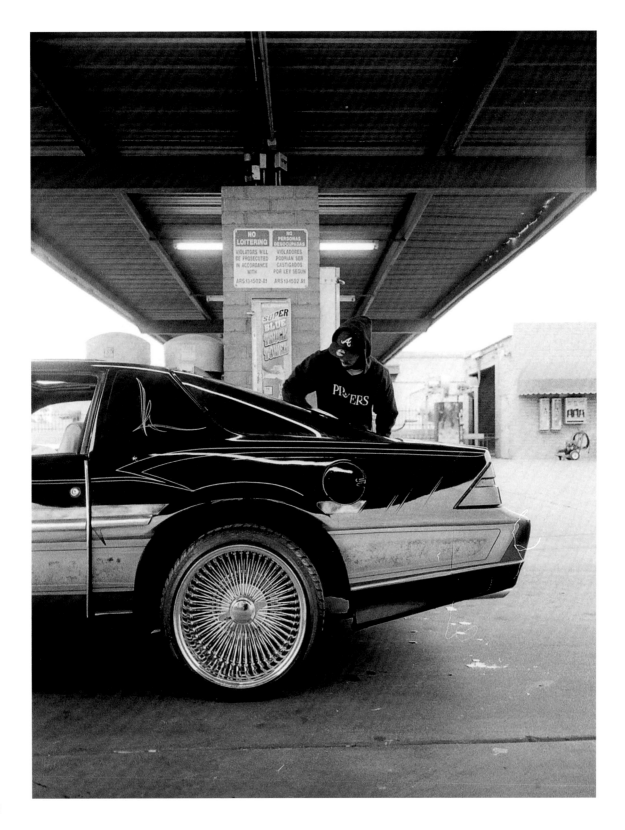

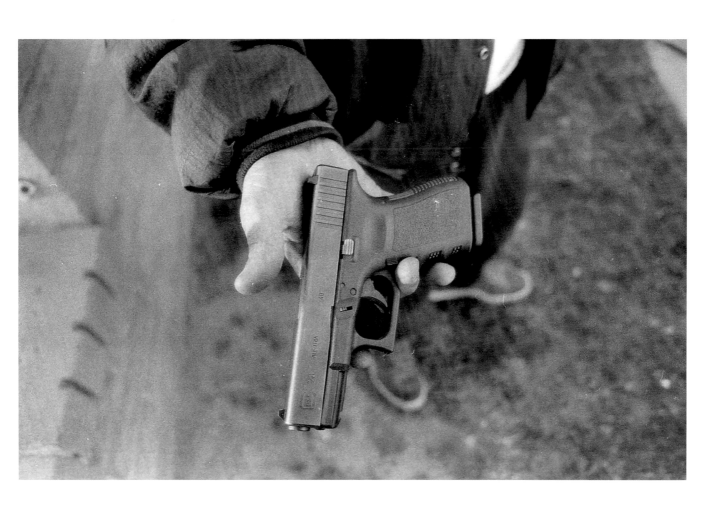

the poem lied about guns.

the poem is cool with guns

as long as the homies got guns.

one day, we might melt bullets into birdfeeders.

today, the sky bursts & that isn't fireworks, homie.

in another life, we can't tell the difference.

in this one, we ink our neighborhoods

onto our skin.

throw up the set like viejitas throw up prayers: birds!

red-winged birds stoned. off the smoke. off the throne.

the poem laughs when police ask for papers.

papers?

papers are for smoking, homie.

here, where you from is a threat, homie.

here, everything you need to know

is written on the body, homie.

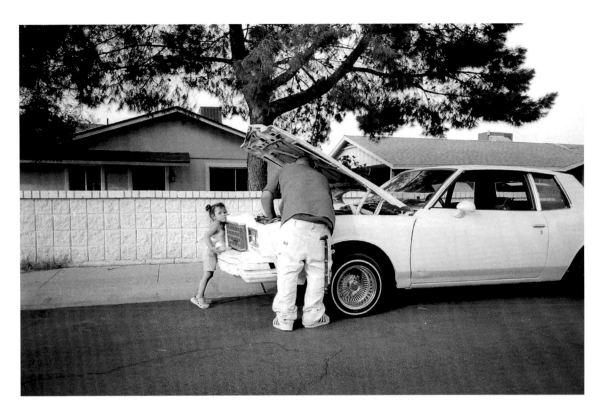

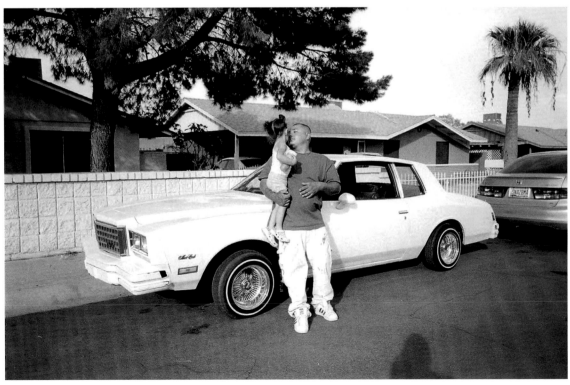

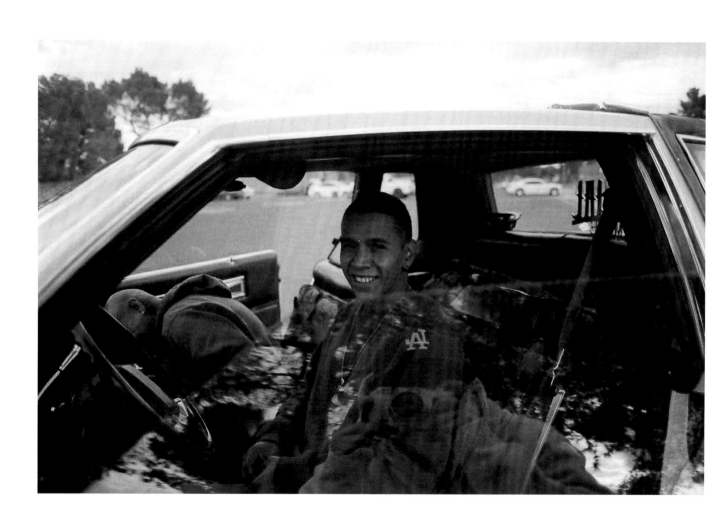

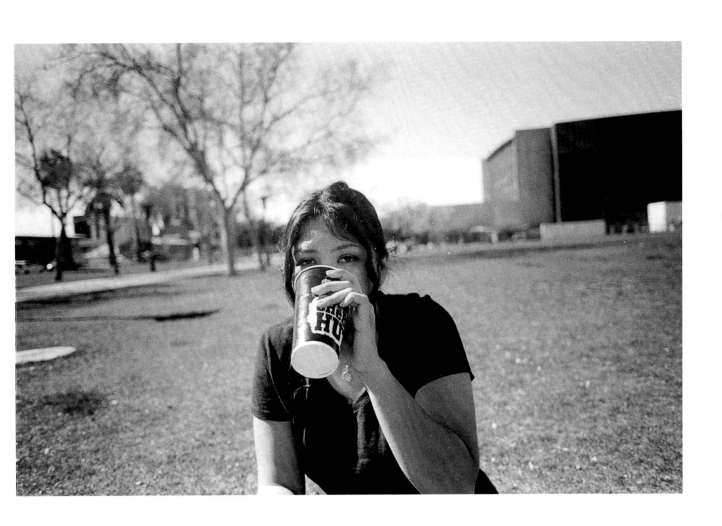

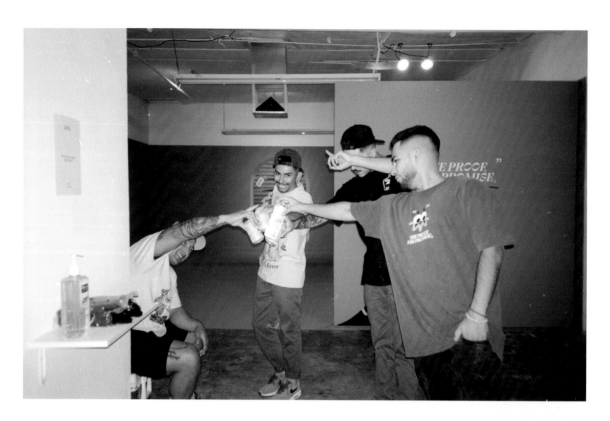

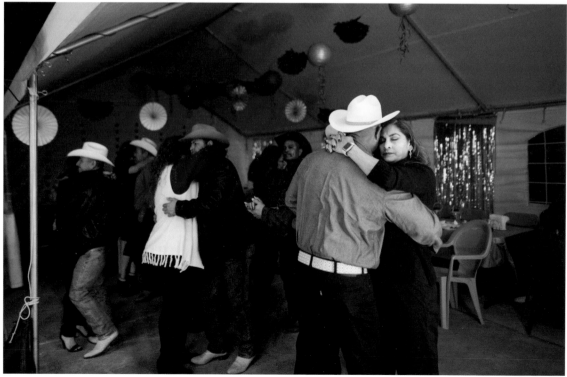

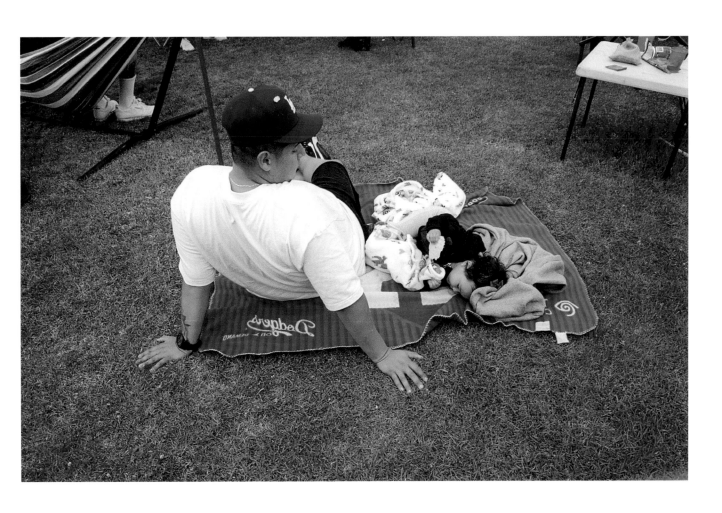

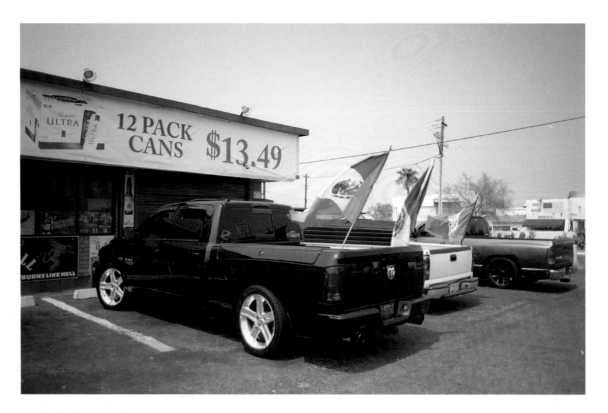

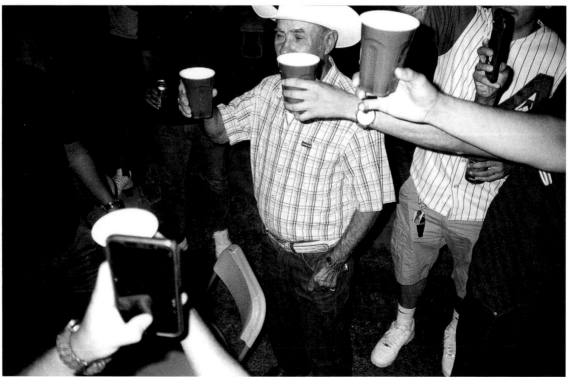

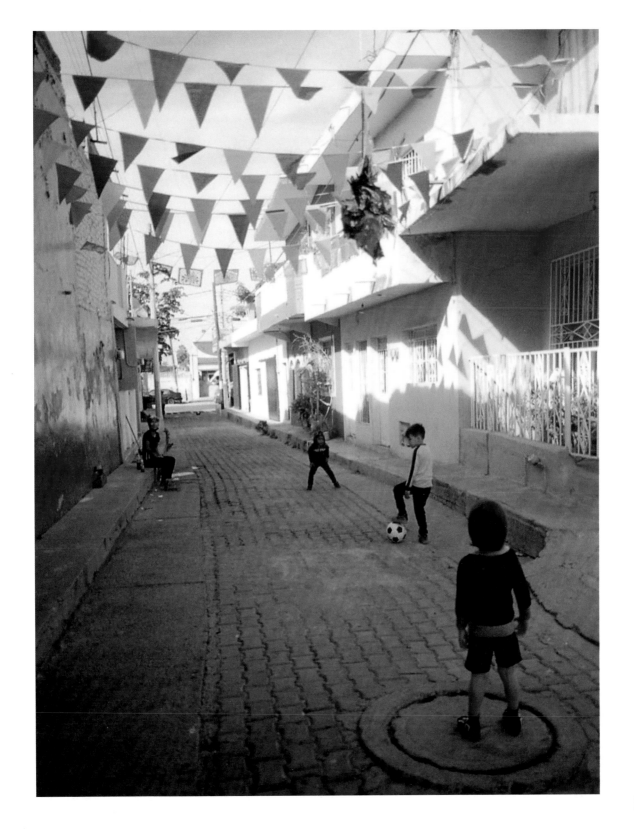

the poem wants to talk about distance. consider
that distance isn't just physical. consider
how the opening notes of "Back That Azz Up"
transport you to a sweaty basement. your hips shift
in your seat. (note: if "Back That Azz Up" means nothing to you,
this poem is not for you.) The distance closes.

some distances can't be closed by a song or a plane.
bless our parents taking shots while we pretended to sleep.
those nights always started with cumbia
& ended with Pedro Infante or Vicente Fernández.
oh god! They sang with all of the miles & years
& losses between them & México.

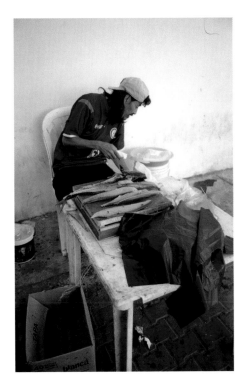

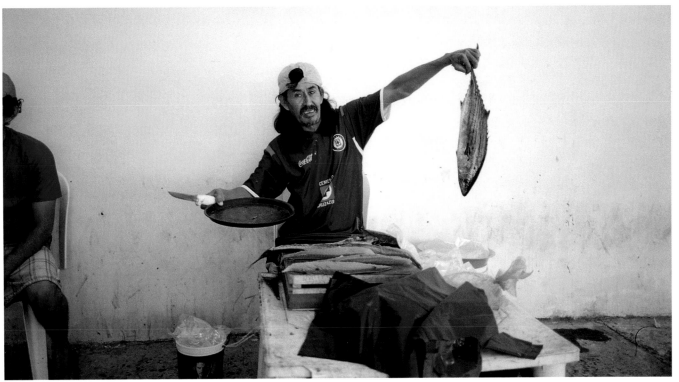

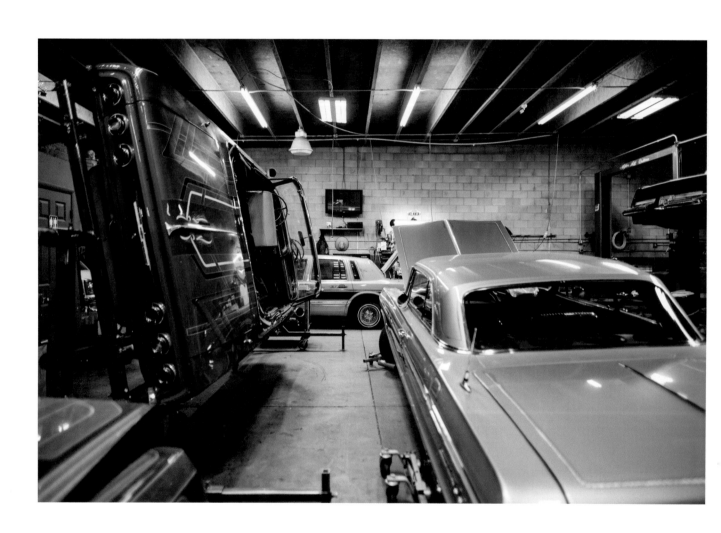

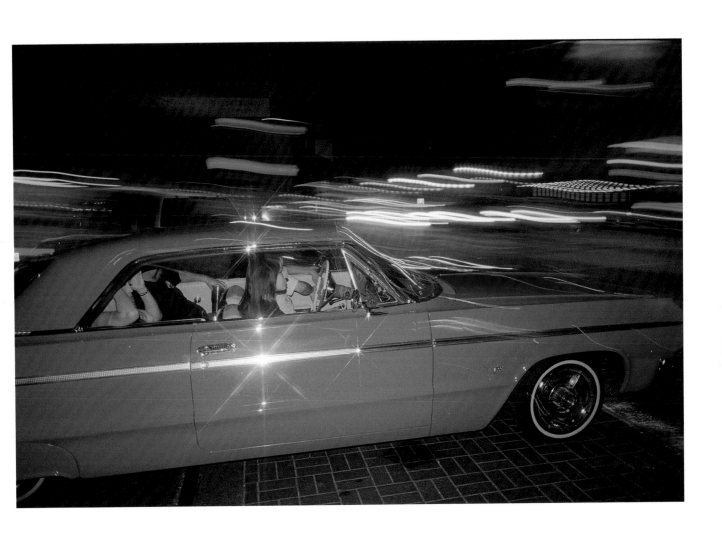

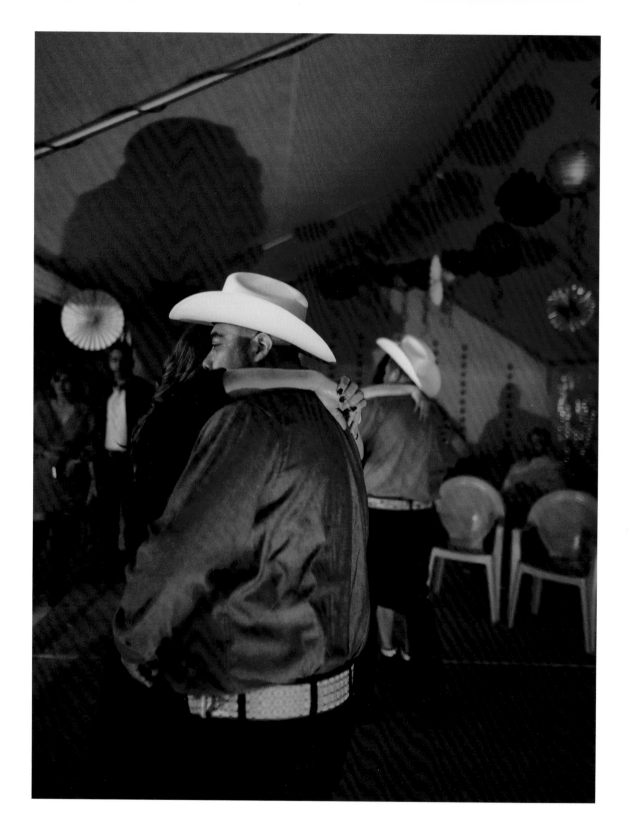

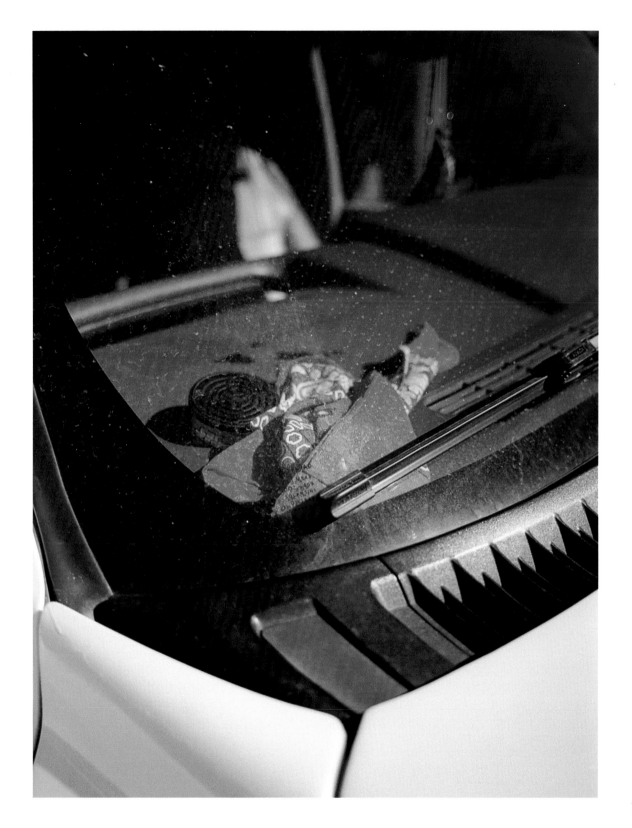

the poem wants you to know
we have systems too.
game systems. sound systems.
when Beto comes down the block
you can hear him two blocks away.
if he's in love, he's blasting Jenni Rivera.
if he's heartbroken, he's blasting Jenni Rivera.
when Nena's parents can't pick her up from school,
we rely on a system: her abuelos take her home to do homework
& watch Jeopardy. after Jeopardy,
Nena's big sister Luz walks her home.
the whole time she's singing "Inolvidable
así me dicen y no son flores." our whole neighborhood
is concrete & that's no marigolds.
still there's Mama Jacinta's garden
where you can get cilantro, tomates, jitomates,
chiles de árbol, y más. if you ask her how she does it,
she would tell you about her system.
that system has a name. its name is love.

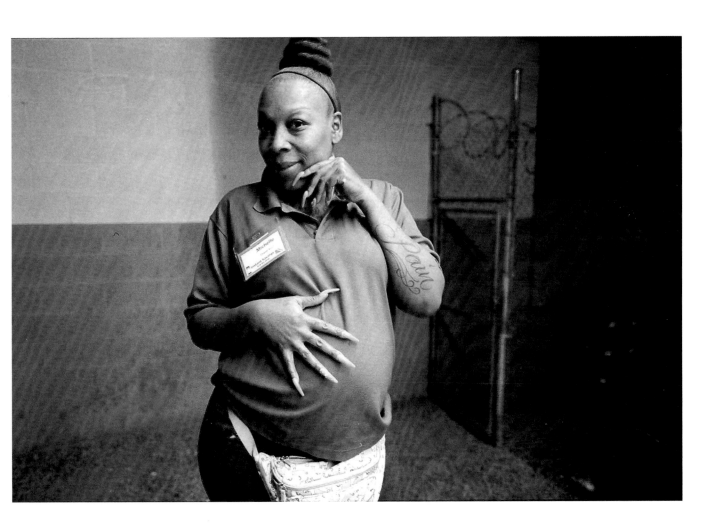

ANTONIO SALAZAR is a photographer living and working out of Phoenix, AZ. His visual art investigates love, parenthood, traditions of the masculine, and the roots of heritage, as well as childhood memories and hard adult living. Salazar has collaborated with surrealist artist and Phoenix-native, Joshua Castañeda, on the Goodtimes Project. His work has been exhibited in *Desert Rider* at the Phoenix Art Museum, *Reel Los Angeles* at Tlaloc Studios, and *Tu Eres Tú* at CAV Gallery in Las Cruces, NM. At the beginning of Salazar's career, the photographer would often wander Phoenix from dusk till dawn. From these wanderings, the obsession with capturing and communicating feelings of place, community, and culture through image came to be. *Por Siempre* is his first book of photography. Find his work on Instagram at @antoniosalazr.

JOSÉ OLIVAREZ is a writer from Calumet City, IL. He is the author of *Promises of Gold* and *Citizen Illegal*. *Citizen Illegal* was a finalist for the PEN/ Jean Stein Award and a winner of the 2018 Chicago Review of Books Poetry Prize. It was named a top book of 2018 by *The Adroit Journal*, NPR, and the New York Public Library. Along with Felicia Rose Chavez and Willie Perdomo, he is a co-editor of the poetry anthology, *The BreakBeat Poets Vol. 4: LatiNEXT*.

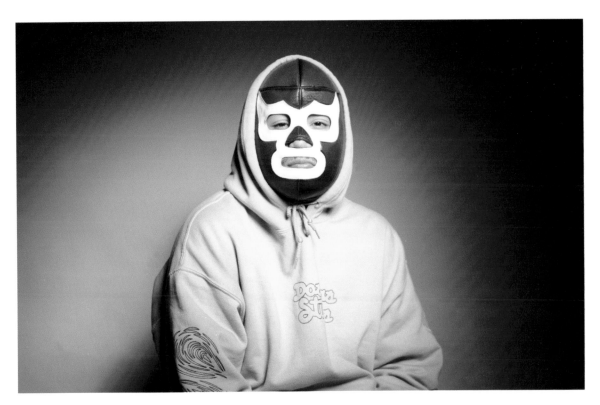

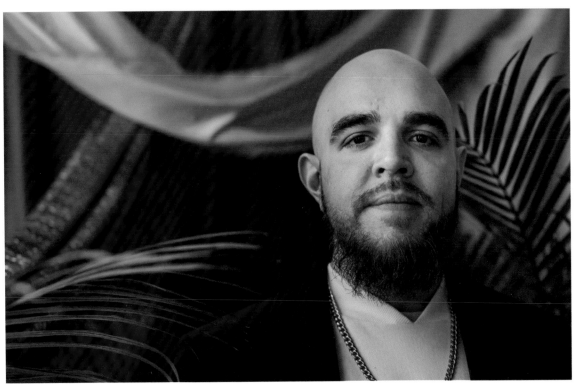

ABOUT HAYMARKET BOOKS

Haymarket Books is a radical, independent, nonprofit book publisher based in Chicago. Our mission is to publish books that contribute to struggles for social and economic justice. We strive to make our books a vibrant and organic part of social movements and the education and development of a critical, engaged, and internationalist Left.

We take inspiration and courage from our namesakes, the Haymarket Martyrs, who gave their lives fighting for a better world. Their 1886 struggle for the eight-hour day—which gave us May Day, the international workers' holiday—reminds workers around the world that ordinary people can organize and struggle for their own liberation. These struggles—against oppression, exploitation, environmental devastation, and war—continue today across the globe.

Since our founding in 2001, Haymarket has published more than nine hundred titles. Radically independent, we seek to drive a wedge into the risk-averse world of corporate book publishing. Our authors include Angela Y. Davis, Arundhati Roy, Keeanga-Yamahtta Taylor, Eve Ewing, Aja Monet, Mariame Kaba, Naomi Klein, Rebecca Solnit, Olúfẹ́mi O. Táíwò, Mohammed El-Kurd, José Olivarez, Noam Chomsky, Winona LaDuke, Robyn Maynard, Leanne Betasamosake Simpson, Howard Zinn, Mike Davis, Marc Lamont Hill, Dave Zirin, Astra Taylor, and Amy Goodman, among many other leading writers of our time. We are also the trade publishers of the acclaimed Historical Materialism Book Series.

Haymarket also manages a vibrant community organizing and event space in Chicago, Haymarket House, the popular Haymarket Books Live event series and podcast, and the annual Socialism Conference.